Claudia Lanfranconi

Girls in Pearls

The story of a passion in paintings and photographs

MERRELL
LONDON • NEW YORK

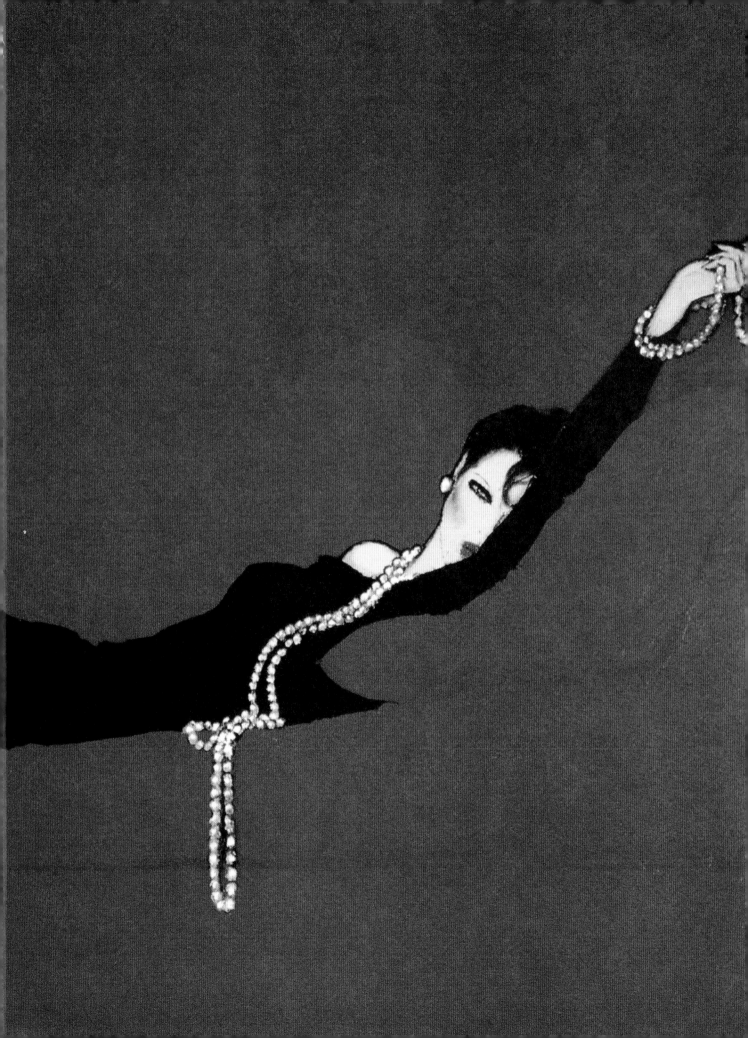

First published in English in 2006
by Merrell Publishers Limited

Head office
81 Southwark Street
London SE1 0HX

New York office
49 West 24th Street, 8th Floor
New York, NY 10010

merrellpublishers.com

Publisher Hugh Merrell
Editorial Director Julian Honer
US Director Joan Brookbank
Sales and Marketing Manager Kim Cope
Associate Manager, Sales and Marketing Elizabeth Choi
Managing Editor Anthea Snow
Project Editors Claire Chandler, Rosanna Fairhead
Editor Helen Miles
Art Director Nicola Bailey
Designer Paul Shinn
Production Manager Michelle Draycott
Production Controller Sadie Butler

First published as *Frauen und Perlen* in 2005
by Elisabeth Sandmann Verlag GmbH, Munich
Copyright © Elisabeth Sandmann Verlag GmbH
Illustrations copyright © 2005 the copyright holders;
see page 152

English-language edition copyright © 2006
Merrell Publishers Limited

British Library Cataloguing-in-Publication Data:
Lanfranconi, Claudia
Girls in pearls
1.Women – Portraits 2.Celebrities – Portraits 3.Pearl
jewelry – Pictorial works 4.Pearls – Pictorial works
5.Women in art 6.Celebrities in art 7.Jewelry in art
I.Title
704.9′424

ISBN-10: 1 85894 350 7
ISBN-13: 978 1 85894 350 3

Translated by Susan Mackervoy
Copy-edited by Elisabeth Ingles
Proof-read by Helen Maxey
Indexed by Hilary Bird

Printed and bound in China

Front cover: Louise Brooks (p. 133)
Back cover, left to right: *Madame Julliard in Red* by Giovanni
Boldini (p. 21); *Thekla, Countess of Thurn-Valsassina (later
Baroness of Schönau-Wehr)* by Marie Ellenrieder (p. 57);
Maria Callas (p. 143)
Pages 4–5: *Sofa Rouge* by René Gruau (courtesy of René
Gruau S.A.R.L., Paris)
Page 7: courtesy of Schoeffel GmbH, Stüttgart
Page 8: *Marie, Queen of Bavaria* by Joseph Stieler (p. 110)

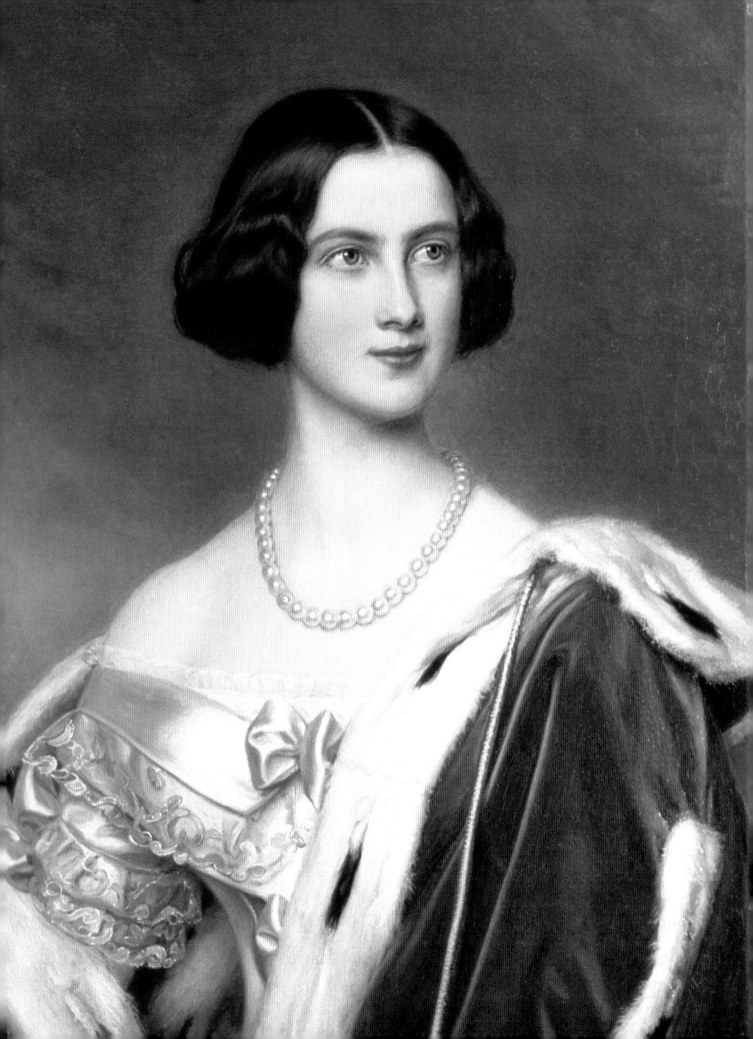

Contents

Introduction

Women and pearls – this is a story that deserves its own chapter in the history of jewellery, in the history of art and, of course, in the biographies of the women who wore the jewels. The Egyptian queen Cleopatra destroyed one of her valuable pearl earrings in order to seduce the Roman commander Mark Antony. In England, after Elizabeth I had Mary, Queen of Scots beheaded in 1587, she promptly took possession of her cousin's magnificent jewels. And arguably one of the most agitated moments of the actress Elizabeth Taylor's life was when a pekinese ran off with her precious pearl pendant, formerly owned by the Spanish and English royal families and given to her by Richard Burton in 1969 as a token of his love.

In past centuries, whole fortunes were lavished on gaining possession of pearls. Pearls have grown naturally and, in contrast to the cool sparkle of a finely cut diamond, they conjure up an enchanting, seductive shimmer on the skin of the women who wear them. Pearls have always exercised an almost magical power over the feminine world; a power that is not attributable to their beauty alone. Large, evenly shaped pearls were rare treasures gathered at great

peril from the waters of the Persian Gulf or off the coasts of India. Laden with weights, the local divers were lowered to the seabed, where they searched for pearl oysters until their breath gave out. They repeated the process – as Marco Polo recorded on his travels in the Far East in the thirteenth century – as many as one hundred times a day, many of them drowning from exhaustion or attacked by sharks.

We cannot know for certain when the first pearls were discovered. Probably one of our ancestors came upon them quite by chance, when eating the flesh of an oyster. The oldest piece of pearl jewellery known to us today is more than 4300 years old. It was found during archaeological excavations in the winter palace of the Persian kings at Susa and can now be admired in the Egyptian Museum in Cairo.

Jewels of Myth and Legend

For centuries no one could explain how such an unremarkable creature as the oyster could produce such a perfectly formed jewel, and as a result the origin of the pearl became shrouded in myth and

legend. In Persian mythology, pearls were regarded as the tears of the gods. The ancient Chinese believed that these 'jewels from the sea' grew by the power of moonlight. Even the great minds of ancient Greece and Rome failed to consider that they might be a biological product made of layers of calcium, holding instead to the belief that pearls were a gift from heaven. Pliny, the author of *Natural History* and the leading scientific authority in the first century BC, was convinced that pearls were created when drops of dew fell into the molluscs. At a particular time of the year, he wrote, the mollusc rises to the surface in order to receive the dew, which then causes a pearl to grow. When the dew was clear the pearl was white; impure dew produced a brownish shimmer. In Pliny's view the weather and the time of day also played an important role. In sunshine the oyster, which dislikes the light, takes in very little dew. Storms put the sensitive creatures in such a panic that they produce air bubbles instead of pearls.

Most authors followed Pliny's pseudo-scientific explanation, because it seemed natural to connect the silvery colour of dew with the pearl's milky shimmer.

However, opinions varied as to the fine details of the formation process and how many pearls an oyster could produce: the rather generous estimate was between five and twenty.

Astonishing as it is, Pliny's dew theory persisted stubbornly in scholarly circles as late as the eighteenth century, although individual doubters raised their voices from time to time. Even Johann Wolfgang von Goethe, a keen scientist, cited Pliny's theory in a collected edition of his poems, published in 1819.

First Attempts at Cultivation

The Chinese were the first to investigate how a pearl grows. As early as the eleventh century AD they were making their first attempts at cultivation using freshwater oysters. In Europe, understanding did not begin to come until several hundred years later, when in 1717 the French zoologist René Antoine Ferchault de Réaumur pointed out that the structure of the pearl was exactly the same as that of the oyster shell. The Swedish scientist Carl Linnaeus took this a stage further, speculating on the basis of his

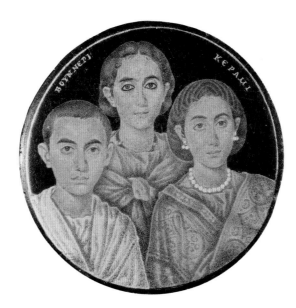

Roman medal with family portrait
Fourth century AD

observations that an oyster drilled with a hole would
cover the wound with layers of mother-of-pearl
to heal itself. King Adolf Frederick of Sweden was
thrilled by his compatriot's discovery and instantly
had hundreds of oysters drilled with holes and
deposited in the sea, hoping that the pearls cultivated
in this rather elementary fashion would alleviate the
sorry state of his country's finances. This attempt did
not meet with success, however.

It was only in 1913, after many experiments, that
the German zoologist Friedrich Alverdes was able to
establish scientifically the exact process by which a
pearl is created. He discovered that pearls are formed
when a foreign body such as a grain of sand or a
parasite penetrates the shell of the oyster. In order
to isolate the intruder and render it harmless, the
sensitive mollusc covers it, layer on layer, with a
substance called nacre (mother-of-pearl), and after
two or three years this produces a round, shimmering
pearl. (While all molluscs can produce pearls, the
true pearl is formed only in certain varieties, of
which the most important is the *Meleagrina* or Oriental
pearl oyster.)

From Rare Jewel to Fashion Accessory

At the same time as scientists were conducting
intensive research into the biological processes
underlying pearl formation, large-scale cultivation
was getting under way in an effort to satisfy the huge
demand for pearls in Europe and America. Japan's
Kokichi Mikimoto may not have been the first person
to succeed in cultivating perfectly round pearls (this
honour belongs to his compatriots Tatsuhei Mise and
Tokichi Nishikawa) but he is nonetheless regarded
as the father of the cultured pearl industry. He ran
the largest pearl farms and founded a global export
business. In fact Mikimoto, who started out as a
noodle-seller, merely wanted to replenish the oyster
stocks in Ago Bay where he lived, which had been
almost totally depleted by the late nineteenth century
because of advancing industrialization and environ-
mental pollution. Then he heard about the Chinese
experiments with cultivation, set up two mollusc farms
and inserted synthetic foreign bodies into hundreds of
Akoya oysters in order to stimulate pearl production.

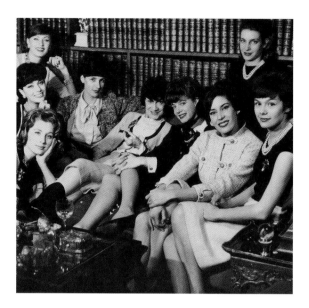

Willy Rizzo

Coco Chanel with her models, Paris 1959

To the present day, cultivation methods have not changed significantly: when the oysters are fully grown, after two to three years, divers bring them on shore where a two- or three-hour operation is carried out to insert mother-of-pearl fragments into the mollusc's mantle tissue. Then the oysters are put back into the sea in baskets, to protect them from such natural predators as conger eels. After another two or three years the oyster flesh is removed and the pearls are harvested. The precious objects produced by this method in the early twentieth century created a sensation. Not only did they surpass natural pearls in size and beauty, they also cost significantly less, because pearl culture on farms was cheaper than the traditional, high-risk pearl-fishing with divers. Kokichi Mikimoto founded his first store selling his new *perles de culture* in Tokyo in 1921 and gradually opened subsidiaries in the capital cities of Europe and America.

Yet it was Gabrielle 'Coco' Chanel who first helped to establish pearls as a fashion accessory for everyday wear, not just for special occasions. After the First World War she created fashions to suit the physique of the new feminine ideal. The women Chanel designed for wanted a look that was practical for work and extravagant at the same time. In her couture house in rue de Cambon, Paris, which opened in 1921, she created jersey dresses with clean, figure-hugging lines and at the same time established pearls as the must-have accessory for the little black dress. Chanel herself, along with her models and sales assistants, provided the best advertisement for this new minimalist, elegant style, as a photograph from 1959 illustrates (above). "Jewellery isn't just there to arouse envy," Chanel used to say, "it must remain decorative, it must be fun."

With new cultivation businesses opening regularly in Japan, China, Tahiti and on the shores of the Red Sea, today's jewellers can offer a wider range of pearls than ever before. Pearls are sold in many different shapes and colours, from silver and gold through pink and champagne to anthracite black. Yet the qualities that determine a pearl's price are still the same: perfectly round or drop-shaped pearls are especially valuable, while small, irregular ones, known as baroque pearls, are less expensive. The most important

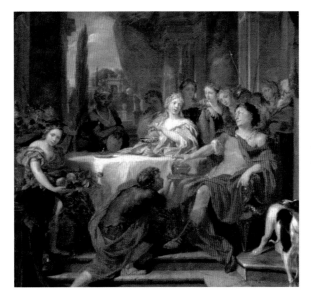

Gérard de Lairesse (1641–1711)
Antony and Cleopatra, c. 1700

The Ultimate in Luxury

criterion of quality after shape and colour, however, is the lustre: the warm shimmer created when light fractures on the dense layer of tiny aragonite crystals.

The Ultimate in Luxury

Nowadays we automatically think of pearls as being specifically feminine jewellery. However, four thousand years ago it was mainly male rulers who used these rare treasures from the sea to display the status accorded them. Pearls were part of the regalia of many great men. From the pictures on ancient reliefs we know that Assyrian and Persian kings had single pearls woven into both their garments and their long beards. Later, Alexander the Great introduced these much-coveted jewels to Greece, following conquests that had brought him to the borders of the Persian empire between 334 and 330 BC. More and more pearls were being imported via the new trading routes between East and West. The Roman rulers, too, from Caesar to Caligula, emulated the pomp with which pearls were treated in the Oriental world. Nero had the interior of his litter lined with pearls; and

Caligula presented a necklace to his favourite stallion. Cloaks, shoes and slippers were decorated with pearls. The Roman pearl trade was so important that the dealers formed their own guild, the *margaritarii* – after 'margaron', the Greek word for pearl.

In Roman mythology, pearls were among the attributes of Venus, goddess of beauty, and so it was natural that all Roman women wanted to wear them. In Caesar's time pearls became the most highly coveted accessory, ushering in a fashion revolution in which no expense was spared. According to the imperial biographer Suetonius, Caligula's wife Lollia Paulina possessed pearls worth 40 million sesterces – the equivalent of £900,000/$1,600,000 today. Less wealthy but status- and fashion-conscious Roman women would do everything they could to wear as many pearls as possible. On a Roman family portrait medallion from the fourth century AD (page 13) we can see how the jewellery was made, with an earring generally consisting of three pearls.

Roman historians and philosophers have also told us a great deal about Rome's craze for pearls. "Pearls, wherever I look", said Lucius Annaeus

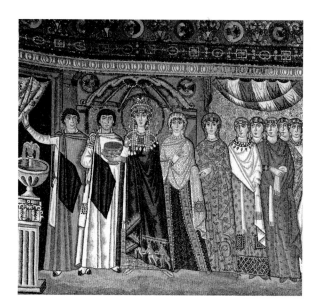

Empress Theodora
Sixth century AD

Seneca. And it is clear that this author – a defender of moral virtues, whose plays showed the disastrous consequences of human passions – could not help being sharply critical of women's extravagance: "Just one for each ear? No! Our ladies' earlobes have developed an amazing capacity for many of them. Two pearls next to each other with a third on top form just a single earring today. These madwomen don't stop tormenting their husbands until they are wearing an entire inheritance on their ear." Pliny, too, was incensed by the lavish lifestyle of his contemporaries: "Nowadays people buy their clothes in China, they search for pearls in the depths of the Red Sea and for emeralds in the earth. Moreover it is the custom to pierce the ears – it is clearly not enough to wear pearls around the neck, in the hair and on the hands, they must be stuck into the body, as well."

Cleopatra's Pearls

Antiquity's most famous woman also possessed its most famous pearls: Cleopatra owned the two biggest pearls ever found. Sadly, however, Egypt's ruler did not take especially good care of her jewellery. After she had abandoned Caesar and turned her back on Rome, she set her sights on her next target, the Roman commander Mark Antony, who was rather slow to respond to her arts of seduction. So she invited him to dinner, promising to serve the most expensive meal of all time in his honour. Yet if Antony expected a gourmet menu of exquisite cuisine, he was disappointed. Cleopatra served up a very simple meal, and when her companion began to mock her, impatiently asking what was so expensive about the food, she called for a cup of strong vinegar and, without batting an eyelid, dropped one of her pearl earrings into it. When the jewel had melted she drank it in a single mouthful. Throughout the centuries, writers and painters – including Gérard de Lairesse, who painted the scene around 1700 (page 15) – have been inspired by this story, which shows not only the irrational side of Cleopatra's character but also her extravagance in matters of love.

Even more rational female rulers did not shy away from showing off their precious pearls in public. On a mosaic frieze in the church of San Vitale in

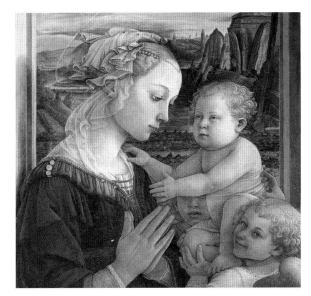

Filippino Lippi (1406–1469)
Madonna with Child and Two Angels, 1469

Ravenna, an anonymous artist depicted the Byzantine empress Theodora, who ruled from AD 527 to 548, wearing her pearl jewellery (opposite). It is not only her crown that is set with jewels: the collar of her cloak is decorated with big round and drop-shaped pearls, which were particularly rare in antiquity and regarded as extremely precious.

Symbols of Purity

During Christian antiquity and the Middle Ages, pearls suffered from their 'luxury' label. Despite frequently being used to adorn altars and such sacred objects as chalices and monstrances, jewellery was frowned upon. Poverty was preached as an ideal; precious stones and pearls were condemned as the devil's work, which would serve only to distract stupid women from true spiritual values. In his first epistle to Timothy, St Paul strictly preached abstinence from all vanities. Christian women should not adorn themselves with "broided hair, or gold, or pearls, or costly array", but rather, "(which becometh women professing godliness) with good works". Similarly,

Clement of Alexandria (*c.* 150–*c.* 215 AD), who wrote many Bible commentaries, vehemently condemned women who valued the products of the oyster more highly than the sacred scriptures. Of course, he conceded, some clever women might protest that it could not be a sin to love something produced by nature, and therefore ultimately by God; but he countered this by saying that God had generously provided humans with everything they needed for a good and useful life, and that He had hidden what He regarded as superfluous. Therefore it was greedy, un-necessary and contrary to God's rules to dive down to the ocean bed to search for a pearl hidden in an oyster.

The guardians of Christian morality condemned pearls as reprehensible luxury objects on the necks and ears of ordinary women. In Bible commentaries, however, and in the visual arts, pearls symbolized Jesus Christ and the Virgin Mary. This religious interpretation was based on two passages from the Gospel of St Matthew. The saying from Matthew 7:6 – "neither cast ye your pearls before swine" – is still commonly used today, although its biblical origin

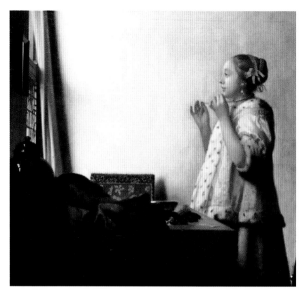

Jan Vermeer (1632–1675)

Woman with a Pearl Necklace, 1664/65

is generally forgotten. Matthew 13:45–46 tells the parable of a merchant who "found one pearl of great price" and sold everything he had to possess it. Such leading religious writers of early Christianity as Clement's pupil Origen (185–254 AD) interpreted the "pearls" mentioned in the Gospel as the word of God or of Christ.

The medieval scholastic philosophers Hugh of St Victor (1096–1141) and Albertus Magnus (1206–1280) were among the first to perceive pearls as a symbol of the Virgin Mary's purity, comparing the pearl's creation in the oyster by heavenly dew with the conception of Jesus in Mary by the Holy Spirit. As a result, the Mother of God is generally shown wearing pearls in the paintings of the Middle Ages and the early Renaissance, as can be seen in Filippino Lippi's *Madonna with Child and Two Angels* (page 17). Even bystanders in a scene, such as accompanying angels, may wear diadems or brooches set with pearls as emblems of their divine purity.

Miraculous Healing Powers

Despite the medieval emphasis on interpreting pearls as a symbol of the Virgin Mary and of Jesus Christ, the influence of the old pagan legends did not decline. Many scholars drew on Classical writings to put together encyclopedic works detailing all there was to know about pearls. They perpetuated not only the myth about the jewels' origins but also the medical powers that had long been attributed to them. According to Thomas à Becket (1118–1170), if they were ground and made into a pill they could remedy stomach problems and diarrhoea. Ingesting or wearing them was recommended for sleeplessness, depression, heart problems and breathing difficulties. Vincent of Beauvais (died 1264) was convinced that they could even help those who suffered from epileptic fits.

Symbols of Power

For most of the pearl-wearers in this book, the therapeutic benefits of their jewels were not of primary importance. From the Renaissance onwards,

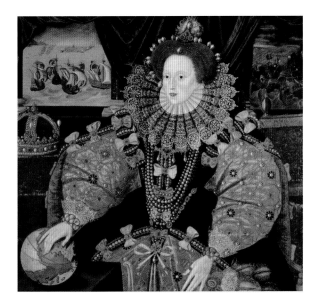

George Gower
(attributed; *c.* 1540–1596)

Elizabeth I, Armada Portrait, 1588

society women adorned themselves with necklaces, diadems and earrings in order to show off their wealth and beauty. The sixteenth century has long been considered the age of pearls. After the discovery of the New World, pearls from the Pacific and from the coasts of Colombia and Venezuela were imported to Europe. In Spain, America was initially known as "the land of pearls". In the seventeenth century, the main Dutch ports became pearl-trading centres. Jan Vermeer depicted an emerging class of wealthy, class-conscious dealers and merchant families in his paintings. In 1664 he painted a young woman with her status symbols – a yellow satin dress with an ermine collar, and a pearl necklace (opposite).

Queen Elizabeth I, daughter of Henry VIII, was arguably more status- and image-conscious than any woman in history. She is said to have owned more than 3000 dresses embroidered with pearls and eighty wigs set with them. She had countless portraits painted showing her in her jewels and finery. On what is known as the Armada Portrait (above), dated 1588 and attributed to George Gower, we can see how she wore her jewels: pearls are sewn on to her silk

dress and her neckline is adorned with a lace collar beneath which several long strings of pearls fall to below waist level.

Elizabeth had a reputation for being cruel and ruthless in the pursuit of her political ambitions, and not without reason. Yet an incidental benefit of one harsh decision was to bring her possession of the jewels she loved so passionately. Many of her necklaces had previously belonged to her Catholic rival Mary, Queen of Scots, who was executed on Elizabeth's orders in 1587. Mary herself had acquired her valuable jewellery when she was married to the dauphin of France, from her mother-in-law Catherine de' Medici, who in turn received it as a dowry from her uncle Pope Clement VII on her marriage to the French King Henri II. The pope wanted his gift to make an impression on the French nobility, because they dismissed the women of the Medici family, which had amassed its fortune from trade, as "shopkeepers' daughters". The head of the Catholic Church did not hesitate for a moment to sell off the biggest diamond in his tiara when a huge collection of pearls came on to the market,

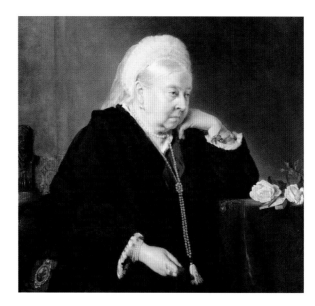

Bertha Müller (1848–1937)
Queen Victoria, 1899

a collection larger than any previously owned by a single person. Unfortunately, his niece Catherine barely had any opportunity to wear items from the magnificent gift, nor was she accorded more respect because of it; her husband gave some of the pearl necklaces to his mistress Diane de Poitiers.

In the courts of Europe, pearls were worn not only as status symbols but also in times of mourning. By the eighteenth century the rituals of mourning were defined in detail according to the degree of kinship. There were precise instructions as to how long the mourning period should last for parents, spouses, children and siblings, extending from a few weeks up to two and a half years. The appropriate colour for mourning dress varied accordingly, from deepest black to shades of grey, which could be offset by white accessories. The jewellery to be worn was also strictly regulated. Pearls were traditionally regarded as appropriate for mourning. A mourning announcement at the Viennese court, following the suicide of Crown Prince Rudolf in 1889, prescribes that the ladies at court were to dress "in black silk, with headdresses and trimmings of white lace and

with real jewellery or in grey and white dresses with black lace and with black jewellery or pearls". Similarly, after the death of her beloved husband Prince Albert in 1861, Queen Victoria ordered that only black jet jewellery should be worn at the English court. She herself combined her mourning dress – which she wore for the rest of her life – with jet necklaces or pearls, as can be seen in the portrait of 1899 by the English painter Bertha Müller (above).

Attributes of Beauty

Pearls mostly, however, served a single purpose: to accentuate the beauty and femininity of their wearer. Madame Julliard, who wears a low-cut raspberry-red dress in a 1912 portrait by Giovanni Boldini (opposite), was not the only society lady in the prosperous years before the First World War to choose simple but precious pearls for her sittings with the Florentine painter. The Paris Exposition Universelle of 1900 ushered in a new golden age for pearls, and at this time the French capital became the world's largest and most sophisticated pearl market:

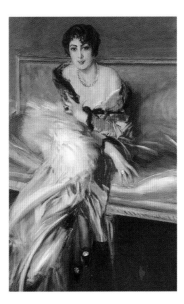

Giovanni Boldini (1842–1931)

Madame Julliard in Red, 1912

even Oriental princes came to the city to display their treasures and to buy beautiful jewellery.

Because of their shape and colour, pearls could be shown to much more impressive effect than cut gemstones in oil paintings. And on canvas they could be shown as larger than life, in accordance with the sitter's aspirations. This portraitist's trick was described by the painter Franz von Lenbach, Munich's 'artist prince' in the second half of the nineteenth century. At dinner with his younger and less experienced colleague Franz von Stuck, he confessed that he had long since acquired the habit of painting pearls as big as doves' eggs to flatter and satisfy his female clientèle.

Even in the modern dream factory, Hollywood, larger-than-life pearls — most of them artificial, admittedly — were used in abundance in the 1920s and '30s in order to enhance the sophistication and mystique of such actresses as Marlene Dietrich and Greta Garbo. Audrey Hepburn wore lavish costume jewellery in her famous role as Holly Golightly in *Breakfast at Tiffany's* (1961), combining false pearls with a little black dress à la Coco Chanel to give herself an aura of brilliance and glamour in the hurly-burly of New York society.

By contrast, Elizabeth Taylor (page 22) wore a superstar's jewels from the very beginning of her career, even when off-screen. She owns one of the world's most famous pearls, La Peregrina ('the pilgrim'). In the sixteenth century the Spanish conquistador Vasco Nuñez de Balboa appropriated this enormous jewel from a slave on a small island in the Gulf of Panama, and, having fallen from favour, presented it to the Spanish King Ferdinand V with an eye to mending his fortunes. A century later, Ferdinand's successor, Philip II, presented it to his English wife, Mary Tudor. After this the legendary jewel was owned by a succession of kings and queens, until Napoleon III's financial straits forced him to sell it. Richard Burton acquired La Peregrina in an auction and presented it to his lover and leading lady in 1969.

Grace Kelly's style was altogether more discreet. In the 1950s and '60s she was a trendsetter whose pearls seemed to be an emblem of her fame. After her fairytale marriage to Prince Rainier of Monaco in 1956, pearls were her favourite accessory, a fact

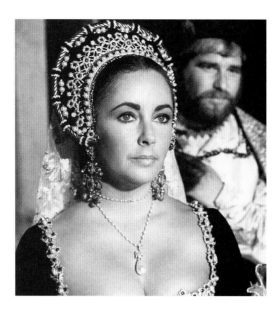

evident from the many photographs of her in the popular press. She even wore them with a bikini, on the beach for a private swim, as we see in Howell Conant's photograph from 1955 (opposite).

Pearls are the perfect vehicle through which women can express their fantasies. According to mood and circumstance they can give a woman the worldly glamour of a great seductress or they can epitomize prosperity, tradition and social power.

False Splendour

Very large, flawless pearls were rare and costly before it was discovered how to cultivate these jewels, and so people naturally tried to imitate them. In Classical times, beads were coated with a layer of glass and silver to make them look like natural pearls. In the thirteenth century, such leading alchemists as Arnaldo de Villanova (*c.* 1240–*c.* 1311) and Roger Bacon (*c.* 1214–1294) attempted to create imitation pearls. In the Renaissance it was of course the legendary *uomo universale* Leonardo da Vinci (1452–1519) who developed a formula for producing the very large pearls that were popular for headdresses and necklaces. In the *Codex Atlanticus*, written during his time at the court of Ludovico il Moro in Milan, Leonardo gave instructions for turning small, cheap pearls into large ones. One simply had to dissolve the cheap pearls in lemon juice, allow the essence to dry and use egg white to bind the resulting powder into a large, regular sphere. Today we might have justifiable doubts as to the durability of a product created in this fashion, yet Leonardo's idea probably sounded quite plausible to his contemporaries.

It did not become widespread, however, because at around the same time the Venetians developed a much more efficient method of imitation. They filled glass spheres with liquid mercury and the results sold like hot cakes, until a French rosary-maker named Joquin came up with an even better filling: pearl essence, or *essence d'orient*. This consisted of scales of herrings and sardines, mixed with lime. With it the Frenchman achieved a lustre very similar to that of a natural pearl. Seventeenth-century imitators sought to satisfy not only the increasing demand for pearls, but also the vagaries of fashion: they imitated the irregular shapes

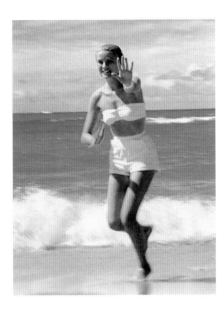

Howell Conant
Grace Kelly, 1956

of baroque pearls by passing round pearls through a dove's digestive tract – with corrosive effect – and then heating them in a fish bladder. This dubious practice has fortunately not survived. But even today, imitation pearls, called Majorca pearls, are produced by dipping glass beads into a glaze made of fish-scales.

The pearls worn by the women in the paintings and photographs reproduced in this book are mostly genuine and in many cases extremely valuable. Yet even when they are clearly imitations, we should bear in mind a quotation from Jean Giraudoux's 1945 satire on speculators, *The Madwoman of Chaillot*. When asked whether her pearls are genuine, the duchess replies: "Everyone knows that little by little, as one wears pearls, they become real."

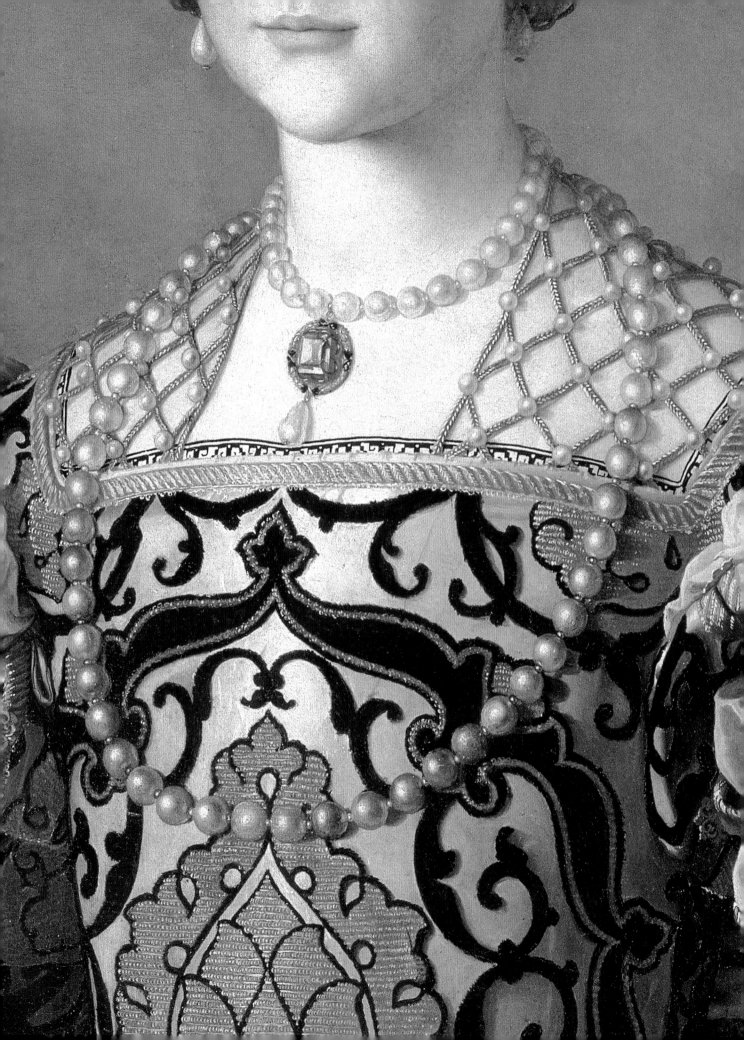

The Ultimate in Luxury
Society Ladies and Anonymous Beauties

The sixteenth century is widely regarded as being the age of pearls. The discovery of the New World provided a new source of these coveted treaures from the sea, which were soon imported to Europe. Not since Roman times had women been so passionate about pearls. The bourgeoisie in particular, with its new-found wealth, revelled in displays of costly jewellery and sumptuous fabrics. In an attempt to keep this luxury in check, both Venice and Florence issued 'pearl laws' stating that only the ruling families were allowed to wear these jewels. Yet there was no holding back the tide; the shimmering gems swept everything before them, as can be seen in the portraits that follow.

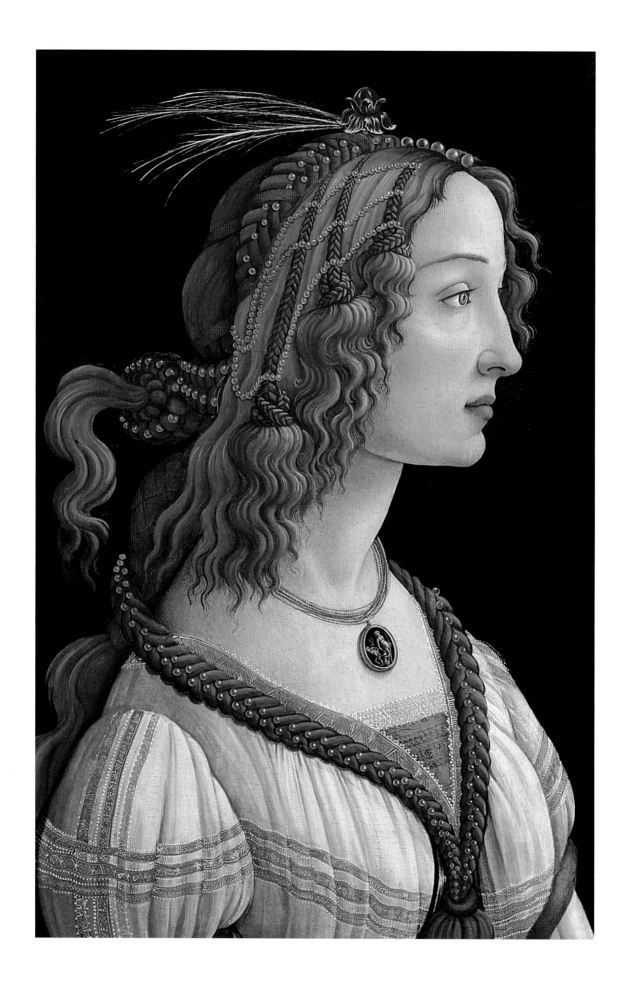

Sandro Botticelli

Sandro Botticelli is famous for creating some of the most beautiful female images of the Renaissance, in paintings such as *The Birth of Venus* and *Primavera*, both of which can today be admired in the Uffizi in Florence. Yet art experts have not yet been able to discover the identity of this lovely woman. Is she a nymph, a goddess, an idealized portrait, a courtesan? Her dress and hairstyle are not in keeping with everyday fashions of the time. She is wearing a white robe, in the Classical style, beneath which the outlines of a breastplate can be seen. Strings of pearls and pink ribbons are woven into the plaits of hair, which meet in a thick braid over her breast, effectively framing her décolletage.

The woman's jewellery is depicted with extraordinary precision. Her hair is adorned with a golden clasp set with heron's feathers, and around her neck she wears a finely cut cameo depicting the Punishment of Marsyas. We know that this antique gem, now displayed in the Archaeological Museum in Naples, belonged to the Medicis of Florence in the fifteenth century. This prompted the art historian Aby Warburg, in the late nineteenth century, to identify Botticelli's subject as the legendary Simonetta Vespucci. Giuliano de' Medici, who ruled Florence with his brother Lorenzo the Magnificent between 1469 and 1492, fell madly in love with this beautiful young woman. Even though she was married, he praised her in poems and even staged a tournament in her honour in 1475. When Simonetta died a year later, at the age of twenty-three, the whole of Florence mourned the loss of Giuliano's beloved.

Sandro Botticelli (1445–1510)

Ideal Portrait of a Woman, 1480–85
Frankfurt, Städelsches Kunstinstitut

Lucas Cranach the Elder

It is mainly from the portraits of Lucas Cranach the Elder that we know about the ideal of female beauty that prevailed at the court of Saxony in the sixteenth century. Cranach went to Wittenberg in 1504, where he was engaged as a court painter by Frederick the Wise. The prince, his family and his court were to be painted in a wide variety of images: in individual and group portraits, as onlookers in devotional pictures featuring Christ and the saints, and in narrative scenes. In 1526 Lucas Cranach painted Sibylla of Cleves, the future wife of Prince Johann Friedrich I, in her bridal costume. With her long golden hair, her fine features, her graceful stature and her aura of virtue, she perfectly matches the feminine ideal as depicted in the chivalric novels so popular at court at that time.

Lucas Cranach the Elder (1472–1553)

Sibylla of Cleves as the Bride of Prince Johann Friedrich I of Sachsen-Weimar, 1526
Weimar, Kunstsammlungen

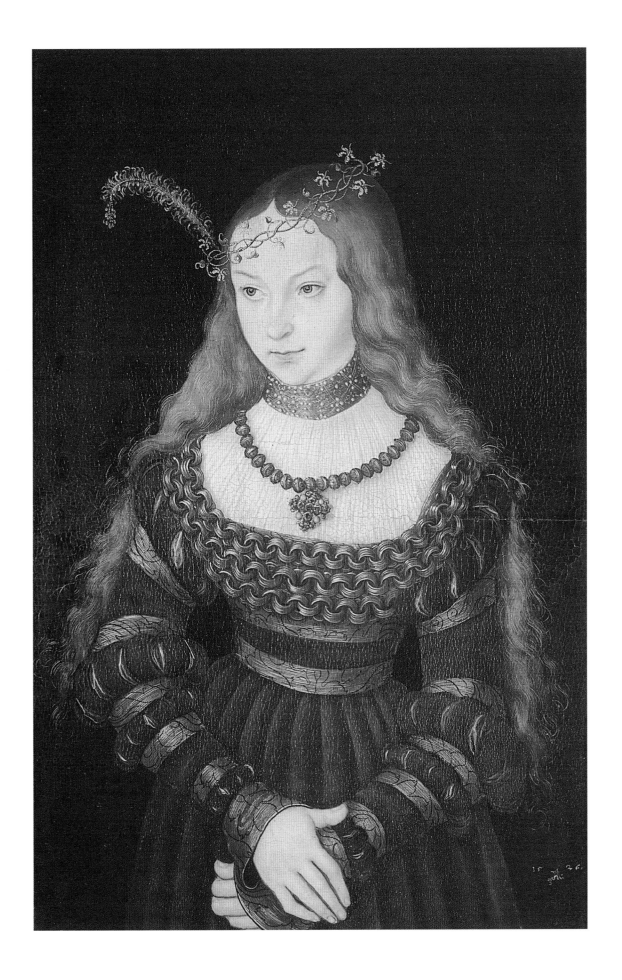

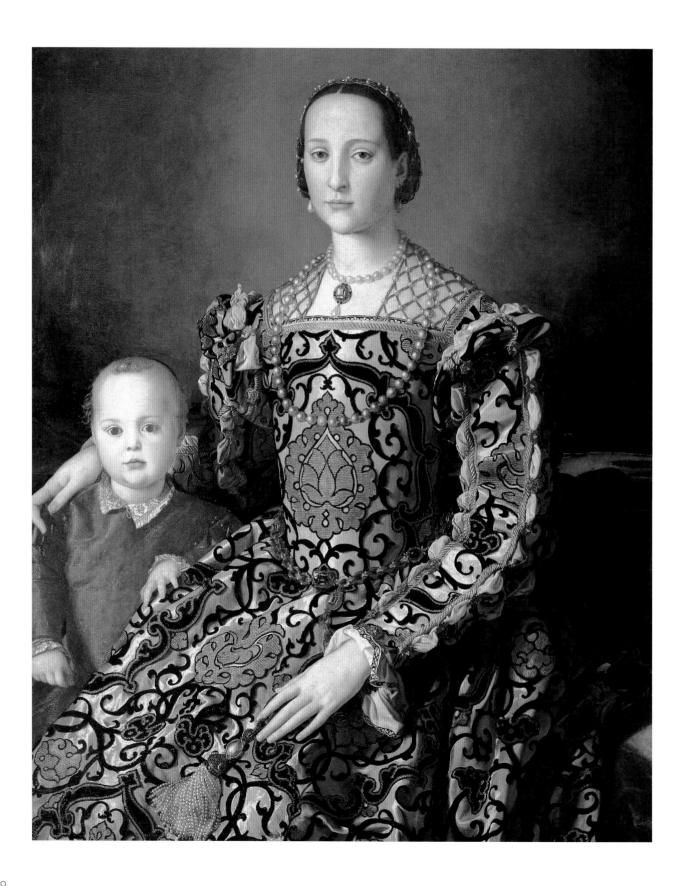

Agnolo Bronzino

As the wife of Grand Duke Cosimo I de' Medici, ruler of Florence from 1537 to 1574, Eleonora of Toledo played much more than just a ceremonial role: in her husband's absence she conducted state business herself. One of the duties she most enjoyed was promoting the arts. She commissioned her favourite painter, Agnolo Bronzino, to paint a chapel in the Palazzo Vecchio. In his cool, restrained style he produced portraits of each member of the ruling family, and these were sent as diplomatic gifts to other European courts. In the summer of 1545 Eleonora had herself portrayed with her youngest son, Giovanni, during a stay at her villa in Poggio a Caiano.

Eleonora wears an elegant brocade dress along with two simple pearl necklaces, earrings and a belt with a pearl tassel. Her sumptuous outfit – which she sent to Bronzino's workshop to save time on sittings – was intended not only to underline her status as Grand Duchess but also as a reference to Florence's dominant position in the textile industry of the time.

Agnolo Bronzino (1503–1572)

Eleonora of Toledo with her Son Don Giovanni, 1550
Florence, Uffizi

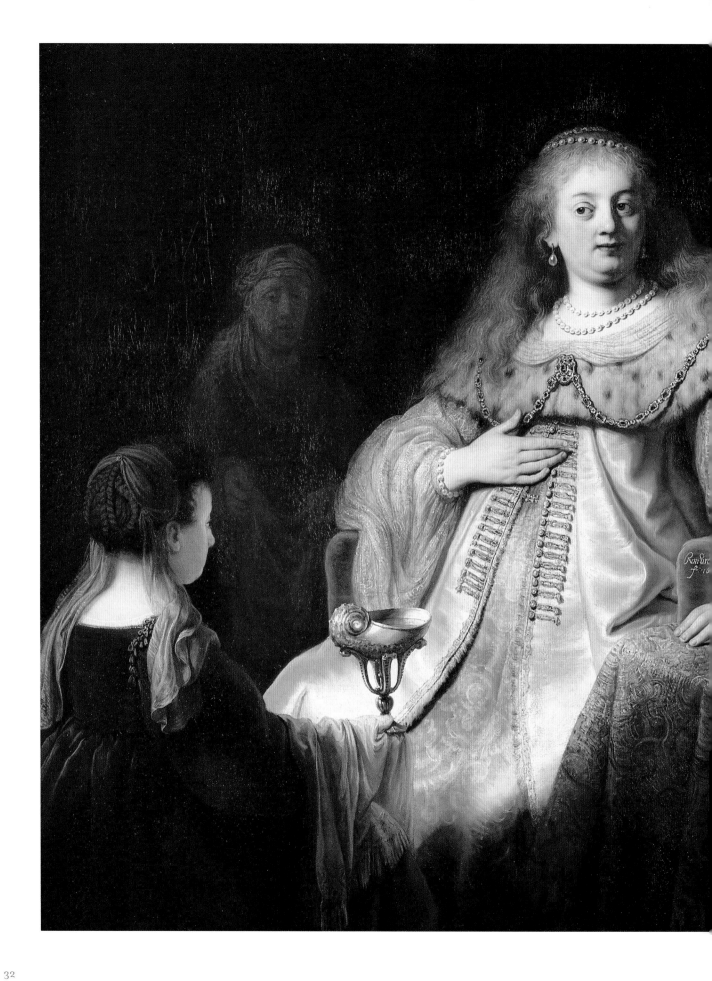

Rembrandt

Her stance and gesture convey power, strength and determination, and the silk dress with its puffed sleeves and wide fur collar accentuates the woman's imposing stature. The thick chains of pearls she wears round her neck and garlanding her flowing strawberry-blonde hair underline her royal status. In this painting of 1634, Rembrandt depicted the tragic story of Artemisia, wife and sister of Mausolos, the ruler of Caria in Asia Minor between 377 and 353 BC, for whom the famous Mausoleum was built. When her husband died, Artemisia's grief was so extreme that she poisoned herself by drinking her husband's ashes dissolved in wine. She is shown here as she is about to take a shell goblet of the poisoned wine from a servant. In the seventeenth century she was seen as a symbol of self-sacrificing love. To capture the drama of the suicide Rembrandt chose a nocturnal setting – as in many of his devotional and mythological paintings – within which the figures are bathed in the golden glow of candlelight. The Spanish Marquis of Ensenada acquired the masterpiece and took it to Spain; and in 1768 it was purchased by King Carlos III of Spain on the recommendation of his court painter Anton Raphael Mengs, who was decorating the royal residences with tapestries and Rococo paintings at the time.

Rembrandt Harmensz. van Rijn (1606–1669)

Artemisia, 1634
Madrid, Prado

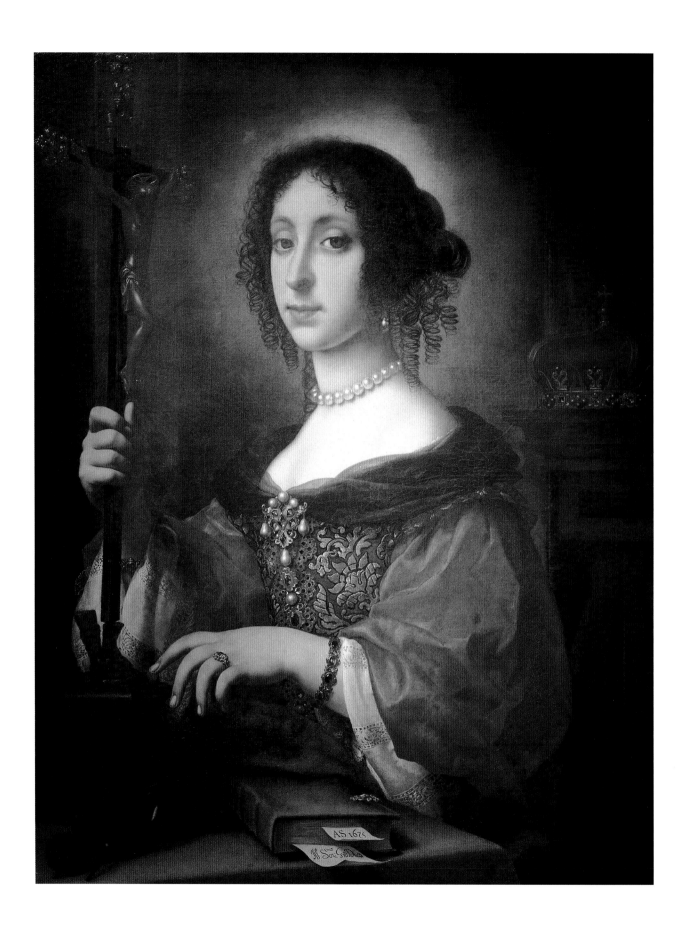

Carlo Dolci

'Role' portraits were very fashionable in the seventeenth century, when society ladies in particular loved to be portrayed as virtuous saints, legendary Classical heroines or goddesses. In 1672 Cosimo III de' Medici asked his favourite painter, Carlo Dolci, to depict the nineteen-year-old Archduchess Claudia Felicita as Galla Placidia. In the staunchly Catholic mood of the Counter-Reformation the Roman empress, who was born around AD 380, was held up as a champion of Christianity, which had become the state religion under Emperor Theodosius around that time. Depicting the archduchess as Galla Placidia was a way of showing her as an exemplary Christian to the educated public of her day.

The two women shared little beyond their faith, however. In contrast to the rather gauche-looking girl, Galla Placidia herself led an extremely adventurous life. When the Goths stormed Rome in 410, she was taken to the court of Alaric as a hostage. Four years later she married his successor, Athaulf, and they lived very happily together in Ravenna. After Athaulf's death in 416 she was ordered back to Rome by her brother, the Emperor Honorius, and summarily married off to his army commander, a man described by contemporary historians as unpleasant. Seven years later, however, when all the powerful men around her had died and her son was too young to take on a ruler's duties, Galla Placidia herself became empress of the western Roman empire.

Carlo Dolci (1616–1686)

Archduchess Claudia Felicita as Galla Placidia, 1672/75
Florence, Galleria Palatina

Anders Leonard Zorn

The Impressionist Anders Zorn created this beautiful portrait of the American arts patroness Isabella Stewart Gardner in Venice in 1894. Isabella and her husband Jack had taken up residence for the summer in Palazzo Barbaro, overlooking the Grand Canal, as they had often done before, and here they received musicians, painters and writers who were inspired by the fairytale atmosphere of this magnificent palace. According to Jack Gardner's diary, on the evening of 20 October they were listening to a concert along with their guests when Isabella stepped out on to the balcony to see a firework display. Enthralled by the sight, she turned round and shouted, "You must all come out straight away — it's too beautiful to miss!"

Zorn depicts this precise moment in his painting, capturing the spontaneity and enthusiasm of Isabella Stewart Gardner's character. She was born in New York in 1840 and supported contemporary artists throughout her life. Her close friends included John Singer Sargent, James Abbott McNeill Whistler and the writer Henry James, who was so taken by her appearance that he included her wonderful string of pearls, which she is wearing in Zorn's portrait, in his novel *The Wings of the Dove*.

Beyond the world of high culture, Isabella Stewart Gardner was a great sports enthusiast and a passionate fan of the Red Sox. And she left a wonderful legacy to her home town of Boston: in 1903 she had a museum built in the style of a Venetian *palazzo* to house her art collection. Now her portrait can be seen there, alongside precious antiquities, Classical sculptures and Renaissance paintings.

Anders Leonard Zorn (1860–1920)

Isabella Stewart Gardner in Venice, 1894
Boston, Isabella Stewart Gardner Museum

Giovanni Boldini

When Boldini, who came from Florence, painted Lina Cavalieri in 1901, her dazzling career as an opera singer was just taking off. A friend of the family had discovered her beautiful voice when she was just fourteen years old and had given her free singing lessons. With a repertoire of three songs the vivacious young girl performed every evening for one lira in a small theatre in Viterbo, helping to boost her family's meagre income. Lina was not just talented; she was also extremely attractive. Soon she was captivating audiences in Rome, Naples, Paris, Berlin and London. During a stay in St Petersburg she made a hasty marriage to the Russian prince Bariatonsky, who forbade her to make further stage appearances, as he thought it did not suit her newly elevated social status. Yet when she received a longed-for offer to perform as an opera singer, she rebelled against her snobbish husband and instantly applied for a divorce. She resumed her stage career and even appeared at the Metropolitan Opera in New York, where she sang alongside Enrico Caruso. Neither of her subsequent husbands, New Yorker Robert Winthrop Chanler and fellow singer Lucien Muratore, could make much headway against her all-consuming work as a singer and later as a film actress. It was only at the beginning of the First World War, when her voice had lost some of its richness, that she allowed herself to slow down a little. She opened a beauty salon in Paris and published a book, *My Secrets of Beauty* (1914), in which she revealed her tips: she added a mixture of salt, glycerine, violet extract and vinegar to her bath, and she slept on a very flat pillow to avoid getting a double chin. Giovanni Boldini shows the opera singer in a melancholy, dreamy mood, a strong contrast to the lively, spirited temperament more generally depicted by others.

Giovanni Boldini (1842–1931)

Portrait of Lina Cavalieri, 1901
Private collection

John Singer Sargent

The men of Britain were clearly divided when it came to the qualities of Lady Helen Vincent. In 1920 the art dealer René Gimpel confided in his diary that she "must be the most beautiful woman in the whole of England". By contrast, the landscape architect Edwin Lutyens, who designed the grounds at the Vincents' home, Esher Place, described her as "hollow inside, dilettantish and utterly superficial".

Sargent, who had a studio in London and had become established as the leading painter of the English aristocracy and the Jewish-American haute bourgeoisie, had some difficulty in producing her portrait. He worked for three weeks on the first version, in which she wore a white dress, and was very unhappy with it. So he changed his mind and within three days painted her wearing a black dress, draped with an opulent pink satin stole. In the portrait, Lady Helen leans proudly against a balustrade, coolly playing with her string of pearls. Sargent produced the painting in Venice in 1904, where he was a guest of the Curtises, great patrons of the arts, in the Palazzo Barbaro on the Grand Canal.

John Singer Sargent (1856–1925)

Lady Helen Vincent, 1904
Private collection

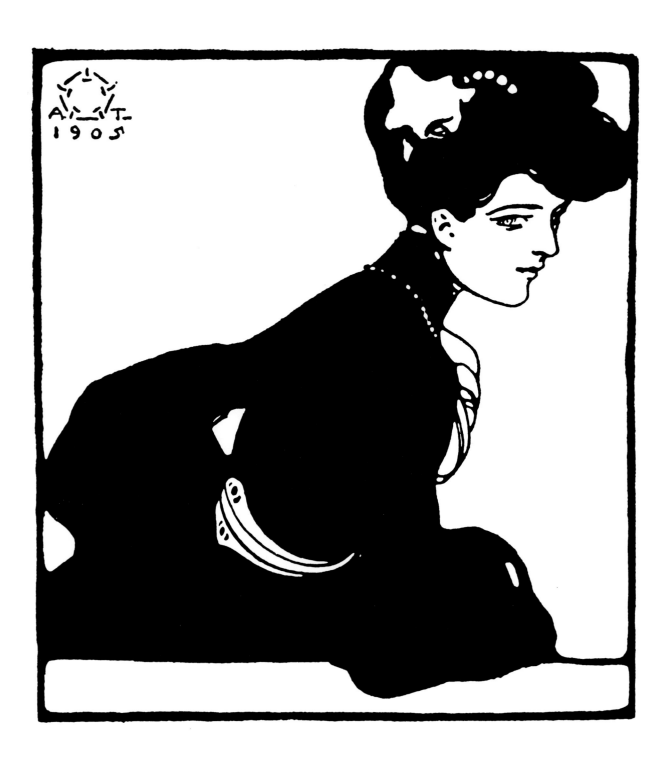

Aleardo Terzi

The Art Nouveau (or *Jugendstil*) movement was taken up early on by such magazines as *Jugend*, which gave it its German name. In *Jugend* (youth), published in Munich from 1896 onwards, the artists produced illustrations in an ornamental, flowing style, rebelling against the imitative style of historicism. The movement quickly spread through many European countries. In Italy, Aleardo Terzi was one of the pioneering figures in decorative book illustration. In 1905 he created the vignettes for the annual publication *Novissima*. This lady looks elegantly over her shoulder, her white jewellery standing out against her black dress. Terzi was mainly known as a poster artist. In 1874 Ricordi, the famous music-publishing firm in Milan, had established its own printing business in order to advertise its operas, and later its recordings. A lithography press was brought from Germany and Adolf Hohenstein was engaged as art director to train Italian Art Nouveau artists, among them Terzi. Soon Ricordi was designing and printing for business customers, too: for Campari, for the Milan daily paper *Corriere della Sera*, and for the Mele department stores in Naples. Terzi created a landmark in poster history in 1914 with his advertisement for Dentol, a picture of a chimpanzee cleaning its teeth.

Aleardo Terzi (1870–1943)

Vignette from *Novissima*, 1905

Paula Modersohn-Becker

Paula Modersohn-Becker's first exhibitions were given a mauling by the critics and she was not even mentioned in Rainer Maria Rilke's monograph on the artists' colony at Worpswede, Germany in 1903. She had moved to the little village near Bremen five years earlier, where such painters as Fritz Mackensen, her husband Otto Modersohn and Fritz Overbeck, along with a few writers, were drawing inspiration from the rural lifestyle and the unspoilt natural environment. Heinrich Vogeler, famous for his idylls, was one of the founding members of the colony and his 'Barkenhoff', a converted farmhouse, became the focal point of social gatherings for these refugees from the city. Paula Modersohn-Becker loved to paint the local farming families as they went about their daily business — people whose rugged looks were far from the conventional ideal of beauty. Art critics around the turn of the century failed to appreciate the forward-looking style of the young artist, who regularly travelled to Paris to study the works of the avant garde. Friends reacted to Modersohn-Becker's portraits with blank incomprehension. Even her husband, who was a successful painter, was sceptical about her simplified style of painting: "The colour's fantastic — but the form? Hands like spoons, noses like clubs, mouths like wounds." Paula Modersohn-Becker made more than fifty self-portraits, both drawings and paintings, in which she avoided any form of idealization.

Paula Modersohn-Becker (1876–1907)

Self-portrait with white pearl necklace, c. 1906
Münster, Westfälisches Landesmuseum

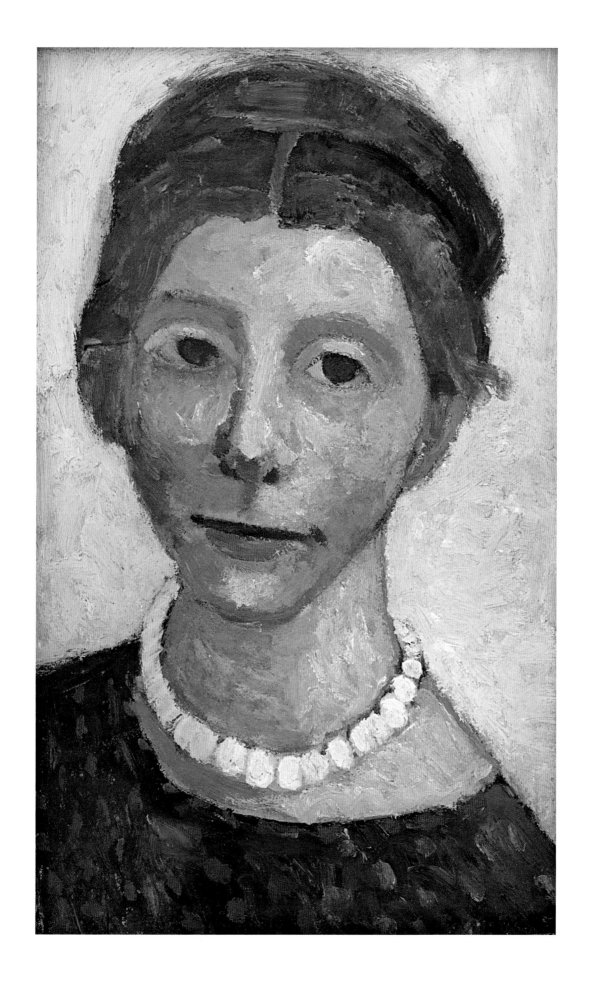

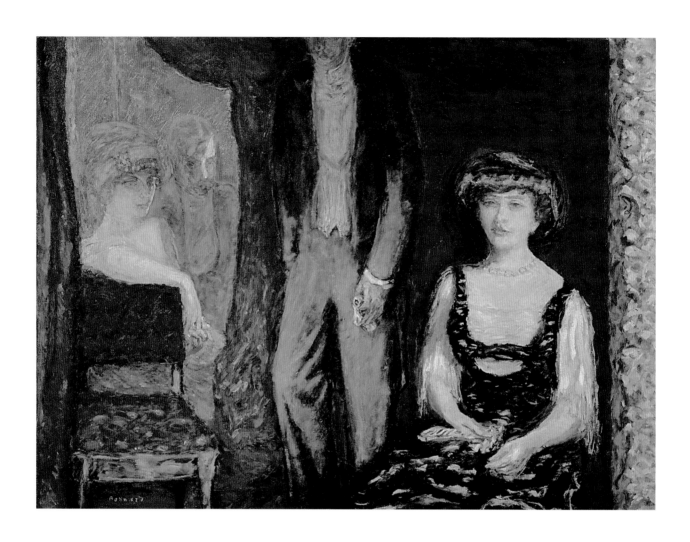

Pierre Bonnard

Pierre Bonnard's most famous works bear testimony to his very close, almost obsessive relationship with his wife. He met her on the street in Paris in 1893; Maria Boursil, aged twenty-six, had changed her name to the aristocratic-sounding Marthe de Méligny to conceal her humble origins. Bonnard had no idea about this change of identity before they married in 1925. Marthe became his favourite model and he produced innumerable portraits of her, at her toilette surrounded by bathing paraphernalia, in dimly lit bedrooms or in the bath. His portraits focused totally on reproducing sense impressions through colours and shapes, following Gauguin's example.

La Loge (The Theatre Box), an unusual subject for Bonnard, was commissioned by the gallery owners Gaston and Josse Bernheim. Their father, Alexandre, had represented Courbet, Monet and Renoir; now his sons were showing works by the Nabis artists and others with great success in rue de Richepanse. The Bernheims wanted a group portrait of themselves with their wives at the opera. However, Josse and Gaston are scarcely recognizable here, while the two wives are given prominence against the orange and vermilion fabric covering the box. Through the dramatic choice of colour and the strangely anticipatory attitude of the figures Bonnard created an unusual air of tension, which contradicts the picture's intended function as a decorative society portrait.

Pierre Bonnard (1867–1947)

La Loge (The Theatre Box), 1908
Paris, Collection Bernheim-Jeune

Auguste Renoir

Renoir's subject in his *Portrait of a Lady with a Pearl Necklace* bears the unmistakeable facial features of Gabrielle Renard, the family's nanny. She had been engaged to help Madame Renoir (her cousin) after the birth of their second son, Jean, in 1894, but her job involved more than just looking after the children and helping around the house: Gabrielle was also Auguste Renoir's studio assistant and model. She can be seen in more than two hundred paintings, sometimes in intimate poses with little Jean, sometimes nude or wearing elegant clothes. In the portrait with a pearl necklace Renoir painted the thirty-two-year-old woman in a graceful, erotic pose, lost in contemplation of her jewellery. It is hardly surprising that his wife Aline's reaction was one of jealousy, and in 1913, after nineteen years, she dismissed Gabrielle. Yet the former nurse was not to be driven away so easily. After Aline died Gabrielle returned and looked after the painter — who was by this stage seriously ill — until his death in 1919. In 1921 she married a wealthy Boston artist, Conrad Hensler Slade (1871–1949), and moved with him to Beverly Hills, at Jean Renoir's invitation, where she died in 1959.

Auguste Renoir (1841–1919)

Portrait of a Lady with a Pearl Necklace, 1910
Private collection

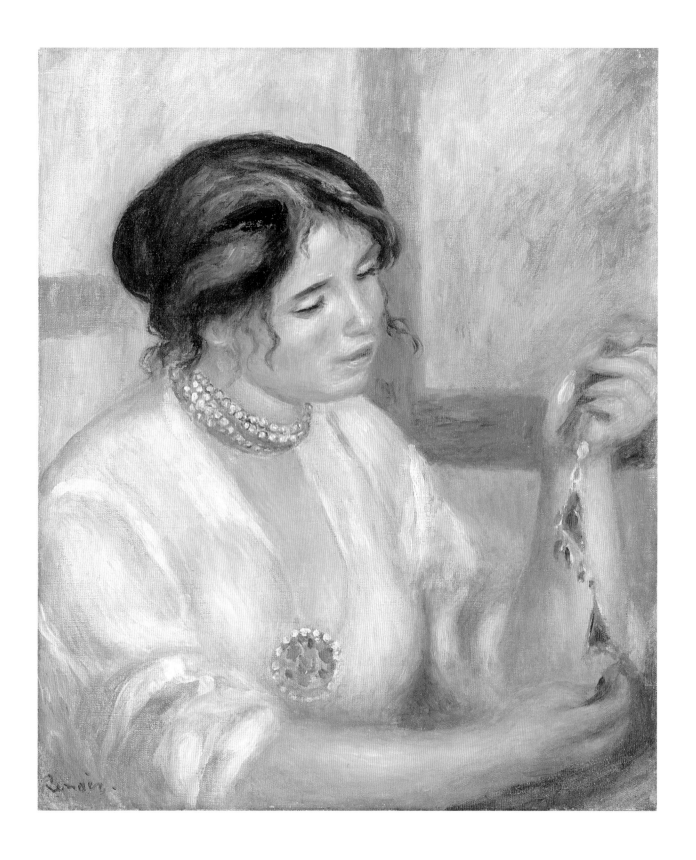

Anita Rée

When Anita Rée returned to her home town of Hamburg in 1925 after three years in Positano, her friends and acquaintances were amazed at her artistic progress. In Italy the painter – who was from a Jewish merchant family – had developed a realistic style influenced by the *Neue Sachlichkeit* (New Objectivity) movement. Before this she had mainly copied the painting styles of her teachers, learning outdoor painting and the Classical genres from Arthur Siebelist. Then Franz Nölken and Friedrich Ahlers-Hestermann, both pupils of Matisse, introduced her to the French avant garde. Anita Rée painted Cubist portraits, landscapes in the style of Cézanne, and still lifes and other images in colours reminiscent of Matisse. It was only in the late 1920s with the painting style she learned in Italy that she began to reach a new clientèle. In 1928 she painted a portrait of Hilde Zoepffel, the wife of a famous Hamburg surgeon. In a reference to Renaissance portraiture, Rée showed the lady with her fashionable hairstyle in half-length against a dark monochrome background. The lace and the pearl necklace are depicted with a technical precision reminiscent of seventeenth-century Dutch paintings.

In the early 1930s Rée withdrew to the island of Sylt following attacks by the National Socialist press. When the Nazis rose to power the artist decided that she could not bear to go into exile and took her own life, aged forty-eight, in December 1933.

Anita Rée (1885–1933)

Portrait of Frau Zoepffel, 1928
Private collection

Symbols of Purity
Children's Jewellery
and Pearls in Christian Art

In the Middle Ages pearls suffered from their 'luxury' label; yet in
the visual arts they came to be employed as emblems of the Virgin
Mary. These beautiful, immaculate natural jewels 'born' inside
the lowly oyster were identified with the virginity of the Mother
of God, and so Mary and her heavenly retinue of saints and angels
were depicted wearing pearl necklaces, earrings and diadems.
Pearls also appeared as emblems of innocence in portraits of
children in the eighteenth and nineteenth centuries. In the
Biedermeier art of nineteenth-century Germany and Austria,
in particular, girls and boys were shown in their Sunday best as
the apple of the bourgeois family's eye.

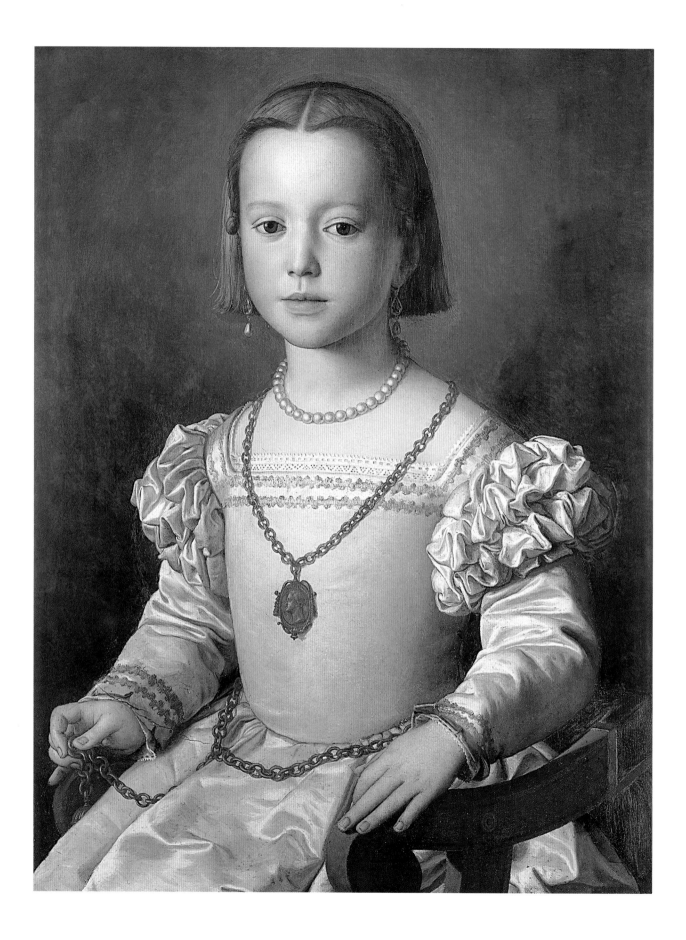

Agnolo Bronzino

Most Renaissance portraits of children were painted in Italy. Initially the children were portrayed as small-scale adults, but during the sixteenth century the images started to become more naturalistic, accurately depicting children's physiognomy, body proportions and gestures. In most cases the children were the offspring of important rulers or wealthy merchant families. This painting shows Bia, the daughter of Cosimo I de' Medici, duke of Florence, in 1542. The court painter Agnolo Bronzino produced a state portrait in his usual elegant style and cool colours. The five-year-old Bia looks straight out at the viewer with a serious gaze and upright stance. Her sumptuous clothes and jewellery underline the formal, ceremonial nature of the picture. She wears a relief medallion with a profile of her father and a pearl necklace round her neck, emphasizing her status as the duke's daughter.

Agnolo Bronzino (1503–1572)

Bia de' Medici, 1542
Florence, Uffizi

Marie Ellenrieder

In 1813 Marie Ellenrieder became the first woman to enter Munich's Academy of Fine Arts. Her admission to this royal institution created a sensation: at that time, daughters of upper-class families who wanted to paint or sculpt generally had to attend private establishments. It was not until 1891 that the Slovenian painter Anton Azbé established a private painting school in Munich that was attended mainly by women (and also by some experimental avant-gardists such as Wassily Kandinsky and Alexej Jawlensky).

Marie Ellenrieder had gradually worked her way towards acceptance by the high-profile Academy. Her mother came from a family of well-known painters and Marie followed in this tradition: she was taught by the miniaturist Josef Einsle in Constance at an early age and specialized in small-format society portraits. In Munich she studied history painting. After a period in Rome, where she was associated with the Nazarene artists and devoted herself primarily to religious subjects, she returned to portraiture, and in 1818 she was commissioned by the princess of Sigmaringen to paint five-year-old Thekla von Thurn-Valsassina. In contrast to later works, where she generally idealized and typecast her subjects, here Ellenrieder succeeded in capturing the inquisitive, playful character of the little countess.

Marie Ellenrieder (1791–1863)

Thekla, Countess of Thurn-Valsassina (later Baroness of Schönau-Wehr), 1819
Private collection, Schloss Bruchhausen

Albert Anker

From 1859 onwards the Swiss painter Albert Anker exhibited regularly at the Paris Salon, the world's biggest-selling exhibition in the nineteenth century, and benefited from the support of such patrons as Napoleon III. He was no bohemian artist, squandering the proceeds of his fame in the establishments of Montmartre; Anker, who had studied theology, lived a thoroughly bourgeois lifestyle. He spent the winter months in Paris and during the summer lived with his family in a thatched farmhouse at Ins, in the Swiss canton of Bern. He loved painting rural subjects, handling them neither as political manifestos nor with rose-tinted nostalgia. He produced around one hundred portraits of children. His daughters Louise, Marie and Cecile were the models he used most frequently, and he captured them in attitudes of quiet contemplation, lost in the moment, as in this picture, *Red Riding Hood*, of 1883. With these traditional genre scenes Anker was able to make a name for himself in the French art market. In 1864 the famous Paris dealer Adolphe Goupil began to sell reproductions of his works. Vincent van Gogh held Anker, who was a few years older, in high regard. In a letter he asked his brother Theo, who was working for Goupil: "Is Anker still alive? I often think of his works, they're so competent, so sensitive. He's still just the same as he always was."

Albert Anker (1831–1910)

Red Riding Hood, 1883
Private collection

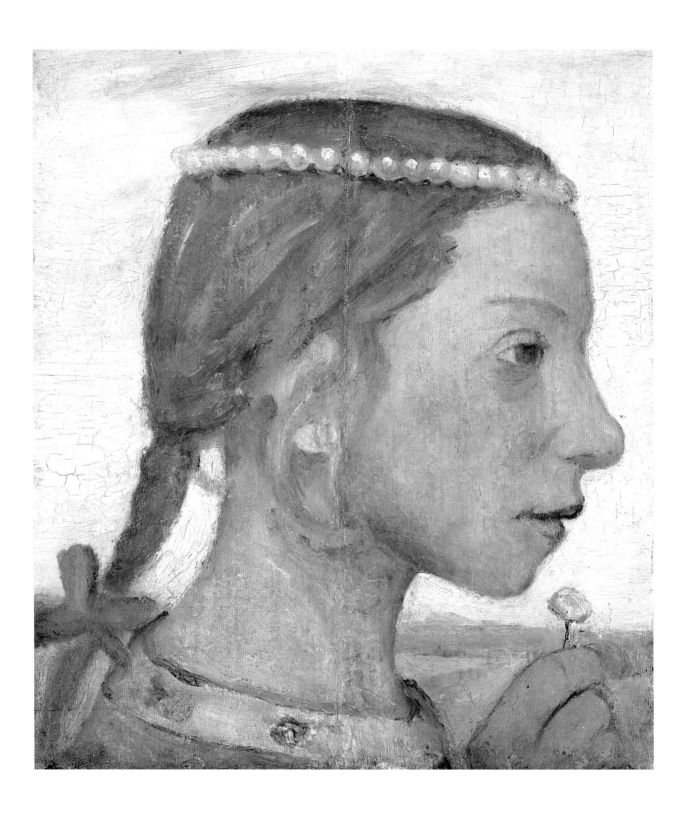

Paula Modersohn-Becker

Children were one of Paula Modersohn-Becker's favourite subjects, and she devoted some two hundred and fifty paintings and drawings to them during her brief career. Most of all she was interested in the children of the local farming families, the children no one else paid any attention to. Following her artistic credo of capturing the essence of what she depicted, she developed an existential, psychologically perceptive approach to her young subjects, entirely discarding the bourgeois ideal of happy, cuddly infants in frilly white dresses. Modersohn-Becker's children are anything but bundles of light and joy. Their melancholy, troubled eyes and serious features call forth protective instincts in the viewer. This young girl with a pearl necklace, painted around 1901, is shown lost in thought, smelling a daisy. Paula Modersohn-Becker did not want to paint nature itself, but people in tune with nature, in the spirit of Romanticism.

Paula Modersohn-Becker (1876–1907)

Head of a young girl with a pearl necklace, right profile, c. 1901
Hamburg, Kunsthalle

Jan and Hubert van Eyck

Even their contemporaries were aware that Jan and Hubert van Eyck's pictures, and especially their greatest work, the Ghent Altarpiece, represented a true turning point in the history of art. The Italian humanist Bartolomeo Fazio hailed the younger brother as 'prince of painters', because Jan van Eyck took concrete, sensual, sun-drenched reality as his point of departure, rather than the abstract, symbolic forms and schemes of the Gothic period. More than any other artist on the threshold of the modern era he created atmospheric, panoramic landscapes enriched with an abundance of botanical and geological features, captured in almost microscopic detail. In portraying people, too, he avoided any idealization, focusing instead on the minutely observed reproduction of physical features and individual character. This meticulous realism prompted speculation that he used optical aids such as the camera obscura, a precursor of the modern camera. Yet he was mainly famous for introducing a new painting technique. By binding colour pigments with oil rather than egg tempera – the standard practice in the Middle Ages – Jan achieved a surface with a jewel-like lustre. His works were traded like rare gemstones. For contemporary viewers this high value was based on a naïve identification of subject and representation: van Eyck put before their eyes a lavish abundance of precious stones, pearls and gold, all painted with virtuoso brilliance, as in the depiction of these angels with strained features, singing God's praises, on one of the twenty panels of the Ghent Altarpiece.

Hubert (1370–1426) and Jan van Eyck (1390–1441)

Ghent Altarpiece, completed 1432
Ghent, St Bavo Cathedral

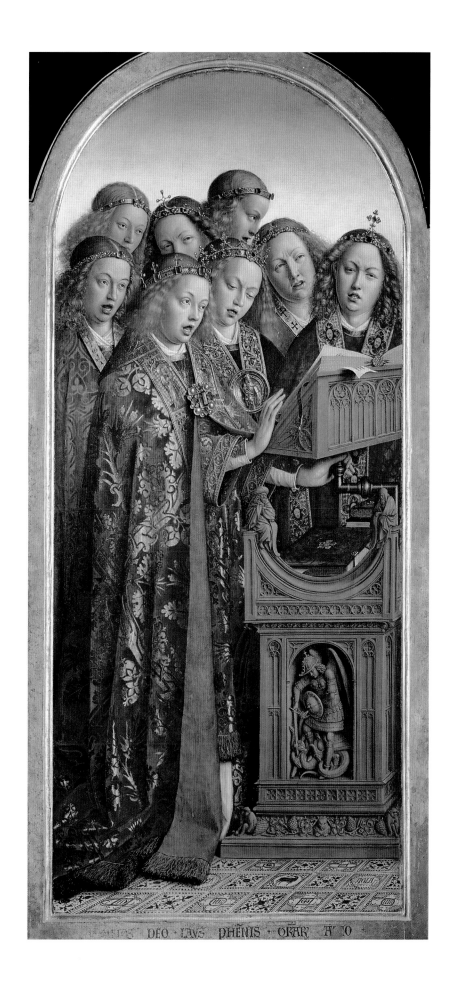

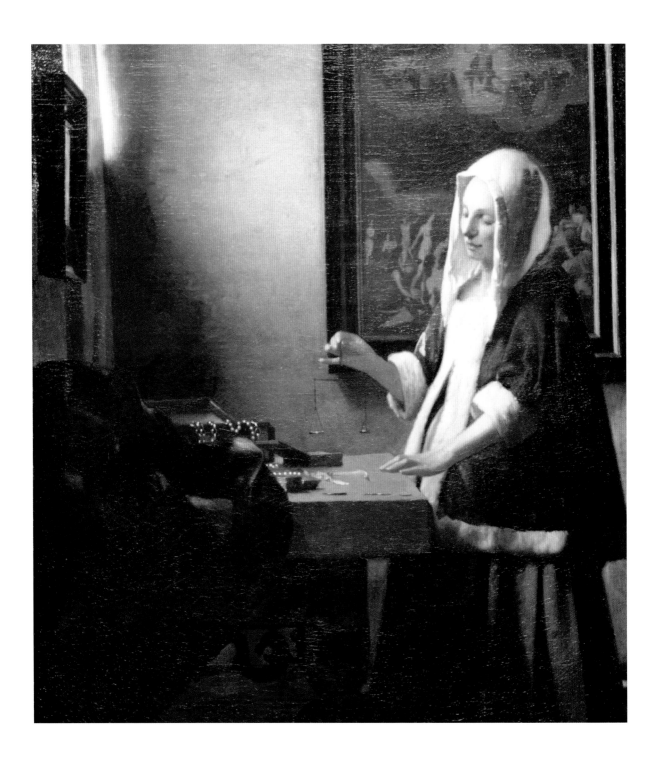

Jan Vermeer

A rt historians originally called this painting by Jan Vermeer *Girl Weighing Pearls*. However, close examination of the picture surface under a microscope shows that the scales are in fact empty. On the table are necklaces and gold jewellery, shining in the daylight that enters from the left. This is not, therefore, simply one of the genre pictures typical of the seventeenth century, an everyday scene showing a young woman or jewellery dealer about her daily business. As in the case of most of Vermeer's pictures the subject conceals within it an allegorical meaning: the pearls can be interpreted as symbols of female vices such as vanity and greed. The picture in the background shows the Last Judgement, and many art historians have therefore interpreted the young woman as a worldly personification of the Mother of God, holding scales that remind us of the transience of life and material riches.

Jan Vermeer (1632–1675)

Girl Weighing Pearls, c. 1664
Washington, D.C., National Gallery of Art

Leonardo Flores

From the Middle Ages onwards, pearls were used in the visual arts as emblems of the Virgin Mary, symbolizing purity. The seventeenth-century Peruvian painter Leonardo Flores, however, seems more concerned with giving his painting a precious, jewel-like quality with the three heavy ropes of pearls that adorn the Madonna's robe. The pearls stand out almost tangibly against the conical shape of the dress. Gold leaf is used lavishly here: the Madonna and Child are set against a brilliant gold backdrop, and covered with a canopy of roses. The brocade robes, too, look as if they have been woven with gold thread. The triumphant Madonna and Child is a typical motif of the Catholic Counter-Reformation and a subject that was introduced to the South American colonies through the influence of Italian and Dutch painters, and above all such Spanish painters as Diego Velázquez and Francisco de Zurbarán. Leonardo Flores's Virgin, with its folkloric style, is a pictorial representation of a miracle-working statue worshipped in the Dominican convent at Pomata, following the Spanish conquest of Peru.

Leonardo Flores (dates unknown)

The Virgin of Pomata, seventeenth century
Private collection

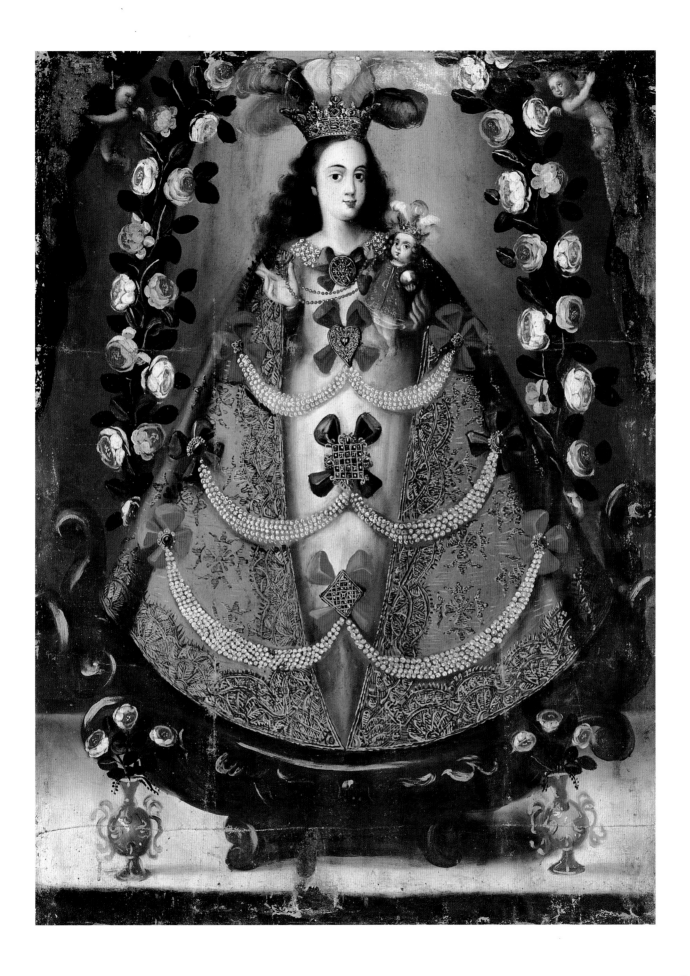

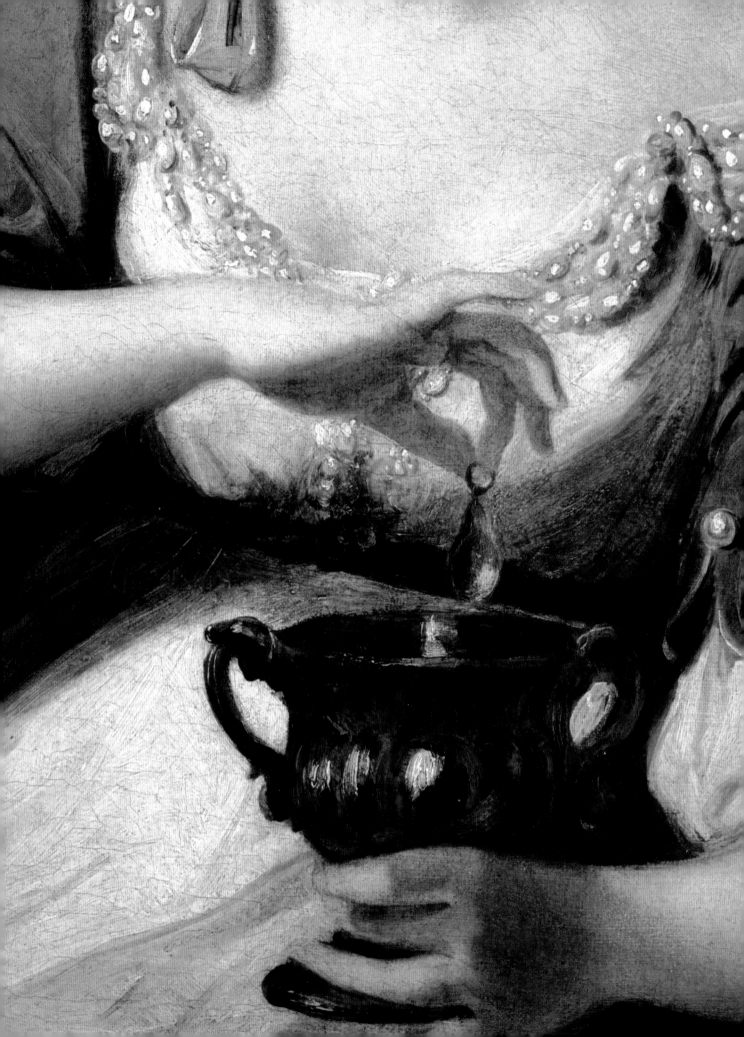

Sinful Pleasures
Seductresses and Courtesans

Four thousand years ago, pearls were worn first and foremost by male rulers to display their wealth and the power vested in them by the deity. It was only later that pearls came to be seen as typically feminine adornments, and in the arts from the Renaissance to the present day they have been used to symbolize the sins and weaknesses traditionally ascribed to women: vanity, greed and extravagance. For painters the main attraction was the opportunity to depict fascinating female characters — the penitent sinner Mary Magdalene, the malicious Salome, or the famous courtesans of the day — in all their seductive glory, in settings to delight the voyeuristic instincts of contemporary viewers.

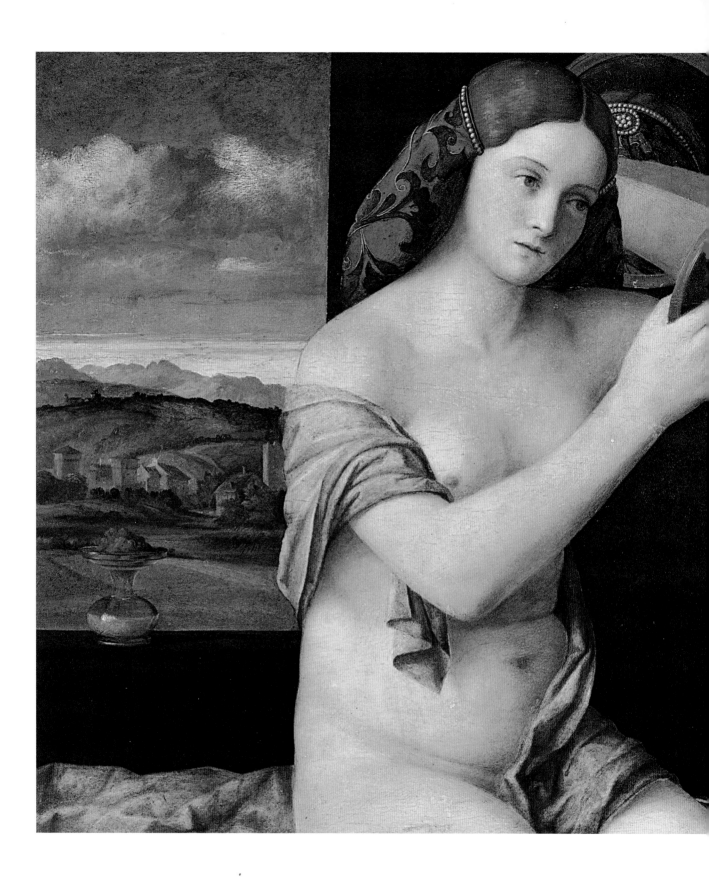

Giovanni Bellini

With this painting Giovanni Bellini introduced a new motif to European painting, Venus at her toilette. This mythological/allegorical subject, showing the goddess in the process of titivating herself, subsequently gave artists of the Renaissance a very welcome pretext for displaying the beauty of a naked woman on canvas. Bellini, who came from a famous Venetian family of painters, placed his young woman against the backdrop of a harmonious, idealized landscape. She is using two mirrors to put the finishing touches to her hair, which has strings of pearls woven into it. These jewels are a reference to the legend of the birth of Venus: when the goddess of beauty emerged from the sea, the spray thrown up was transformed into countless pearls, making them effectively a by-product of her birth. This female nude also reflects the craze for pearls that gripped Venice in the fifteenth century. We know from contemporary reports that Venetian women were obsessed with pearls, so much so that laws were introduced to govern their usage, and for a time pearls could be worn only by the doge's family and by brides on their wedding day.

Giovanni Bellini (1430–1516)

Venus at her Toilette, 1515
Vienna, Kunsthistorisches Museum

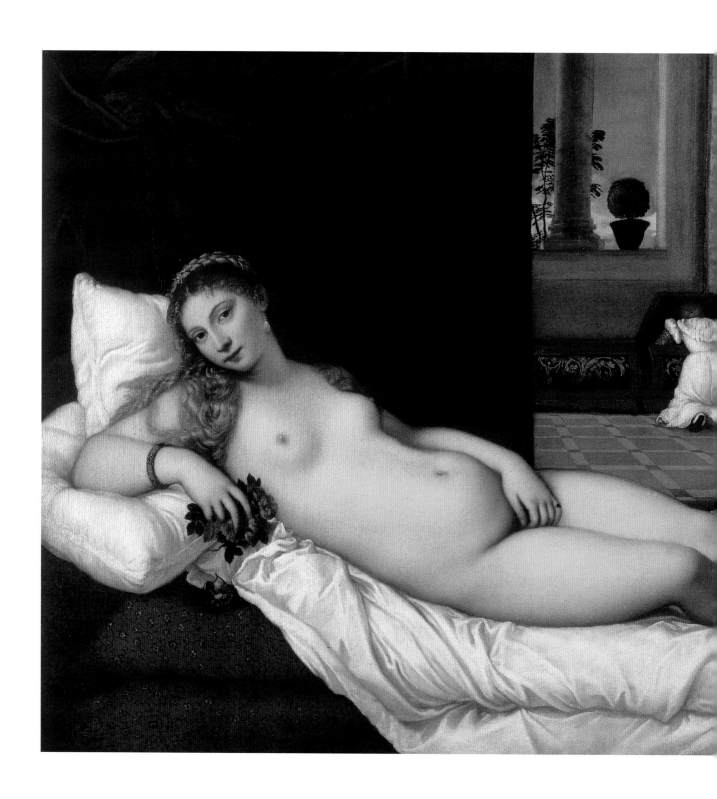

Titian

In the seventeenth century, to view the *Venus* of Urbino was an absolute necessity for educational travellers undertaking the Grand Tour. The painting was displayed in the Tribune gallery in the Uffizi along with the famous Medici Venus, a marble statue of the second century AD. The focus of attention, however, was not the technique and virtuoso colours of the artist, who was already being celebrated as the most important Venetian painter in history. Visitors to the Medici family's magnificent art collection wanted to experience for themselves the picture's renowned erotic effect – a quality heightened by a fabric curtain that showed *amor sacro* preventing *amor profano* from unveiling the painting. Titian's inspiration was Giorgione's *Sleeping Venus*, which can now be seen in Dresden's Gemäldegalerie Alte Meister. However, Titian set his Venus in a magnificent interior and replaced the cupid with a little dog, causing generations of art historians to debate whether he had actually painted the mythological goddess of love or had in effect created a 'pin-up' of a courtesan for the purchaser, Guidobaldo della Rovere. The identity of the beautiful woman with the pearl earrings remains a mystery, but the roses she holds in her right hand were traditionally regarded as the flowers of Venus.

Titian (Tiziano Vecellio; 1488/90–1576)

Venus of Urbino, 1538
Florence, Uffizi

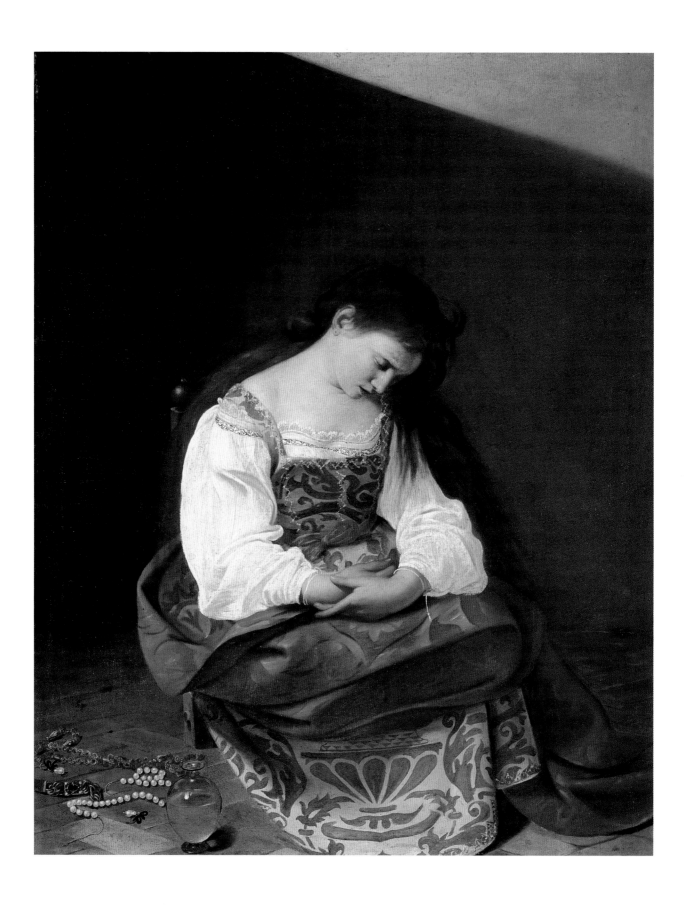

Caravaggio

Michelangelo Merisi, known by the name of his birthplace in north Italy, is one of the most brilliant and fascinating artists of the Baroque. After training in Milan in the studio of a mediocre student of Titian he went to Rome, along with his brother, where a French art dealer saw his pictures and recommended him to Cardinal del Monte. He received his first commissions from this influential patron — naturalistic still lifes with fruit, and small mythological pictures — and with them gained an entrée into Roman society. He became famous overnight with two large-scale altar paintings for the Contarelli chapel in the church of San Luigi dei Francesi. After this he produced works for Rome's most important churches and congregations. Yet his own life was anything but pious: in 1606 Caravaggio killed his opponent in a fight over a bet and fled Rome, heading towards Naples. He spent the rest of his life on the run from the police.

Mary Magdalene is one of his earliest works. The saint sits on a low stool, her hands in her lap and her head bowed in penitence so that her long hair falls forward. On the floor around her lie jewels and strings of pearls that she seems to have cast from her; these are references to her sins of licentiousness and vanity, before her conversion by Jesus and her admission to the group of apostles. The penitent Mary Magdalene, a pictorial demonstration that sinners who had strayed from the Catholic Church could hope for mercy from God, was a popular subject during the Catholic Counter-Reformation.

Caravaggio (Michelangelo Merisi, 1571–1610)

Mary Magdalene, 1594–96
Rome, Galleria Doria Pamphilj

Hendrick Goltzius

Helen's beauty was of the dangerous kind. According to legend, the daughter of Zeus and Leda was abducted at the age of twelve because of her captivating looks, and it seems that just about every Greek ruler attempted to secure her as his wife. In the end Helen married Meneláos, king of Sparta. As so often happens in the Greek myths, this love was put to the test in extreme circumstances. Aphrodite promised the young Trojan prince Paris the loveliest woman in the world if he judged her, Aphrodite – over her rivals Hera and Athena – to be the most beautiful goddess on Olympus. The shepherd-prince could not turn down such a tempting offer: he handed Aphrodite the apple engraved with the words "for the fairest", and carried Helen off to Troy, thus unleashing the ten-year Trojan War described by Homer in the *Iliad* (eighth century BC). For ten years Meneláos's troops laid siege to Troy; then they infiltrated the city hidden inside a wooden horse, a now-famous episode that gave them victory over the Trojans.

The Dutch artist Hendrick Goltzius, whose copper engravings ushered in a golden age of printmaking in The Netherlands in the late sixteenth century, depicted the much mythologized Helen in line with the ideal of beauty that prevailed in his own time. Although her garments and rich jewellery indicate royal status, she holds her left hand to her breast in a gesture of modesty, perhaps also a sign acknowledging the part she played in causing the Trojan War.

Hendrick Goltzius (1558–1616)

Helen of Troy, 1615
Private collection

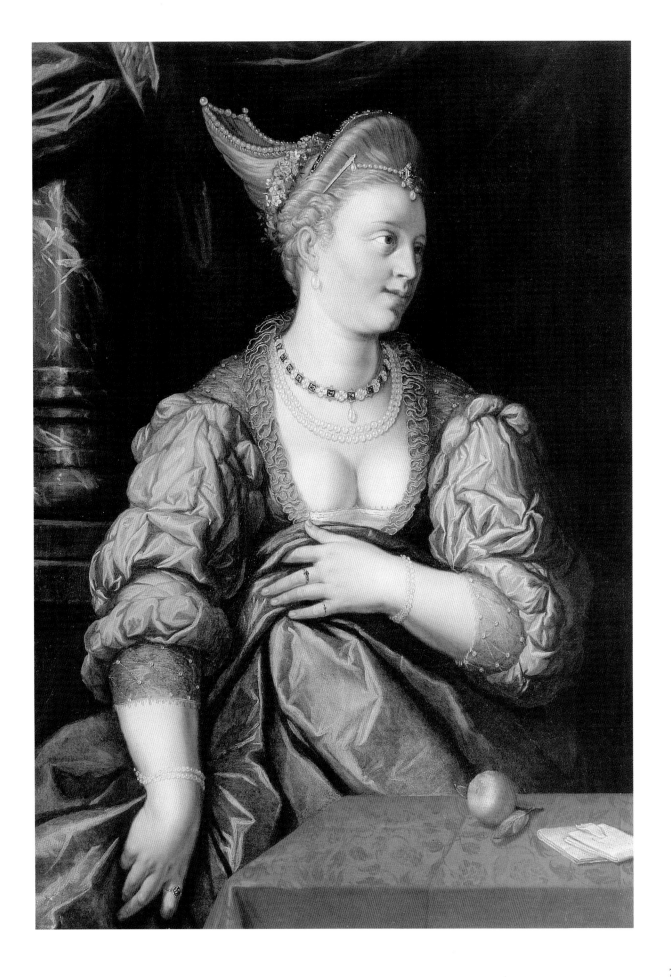

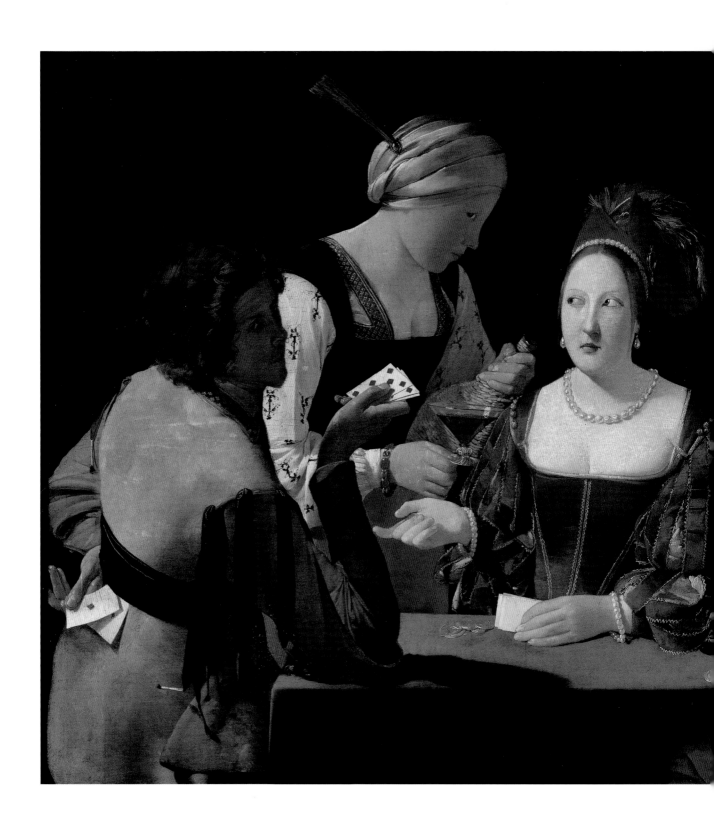

Georges de La Tour

Georges de La Tour, born in Lorraine in 1593, is one of the 'Caravaggists', painters in the first half of the seventeenth century who emulated the innovative nocturnal scenes of the Italian painter Caravaggio. Like his predecessor, Georges de La Tour presented both devotional and narrative subjects against dark backgrounds illuminated with dramatic artificial lighting. Even the genre scene *The Cheat with the Ace of Diamonds* is set in diffuse candlelight. The splendidly dressed young man with a feathered hat on the right of the picture is being fleeced in a card game; the two other players and the maid pouring wine are clearly conspiring against him. The lady wearing the feather turban at the centre of the picture may look convincing enough initially, but in fact her pearls, which are almost certainly false, are designed to give the young man the impression that he is among his own kind. A second look makes it clear that her dress is cut far too low for a respectable society lady. It is much more likely that she is an ageing courtesan who is in league with the card-sharp on the left of the picture. On the one hand the painting presents a moralizing warning against the evils of gambling. On the other, Georges de La Tour offered educated viewers of the Baroque numerous details and subtle clues as to how the story would play out: the ace of diamonds that the courtesan's accomplice has hidden in his belt signifies financial success in the tarot tradition.

Georges de La Tour (1593–1652)

The Cheat with the Ace of Diamonds, 1630/34
Paris, Louvre

Jan Vermeer

We know very little about Jan Vermeer: he was born in 1632 as the son of a prosperous merchant in Delft, trained as a painter, married Catharina Bolnes from a Catholic patrician family in 1653 and spent most of his life in his home town. Yet because Vermeer is one of the most famous and popular painters in European art history these few authenticated facts have become surrounded by a web of conjecture and supposition. Imaginative works of fiction have been written, and recently the film *Girl with a Pearl Earring*, based on the novel by Tracy Chevalier, sought to capture and convey the fascination of his pictures.

In contrast to the turbulent times Jan Vermeer very probably lived through with his large family in the house on Oude Langedijk, his genre scenes radiate an almost meditative calm. Thirty-five paintings are attributed to him today. They show us seventeenth-century interiors in immaculate detail: tiled floors, coloured window-panes, maps, paintings, cutlery, furniture and musical instruments. Yet the identities of many of the men and women who populate Vermeer's light-drenched rooms remain a mystery. The girl with a pearl earring – who is set, untypically, against an almost black background – has been identified by some historians as one of his daughters. In the film she is a maid who helps the introverted artist prepare his paints and sits as a model. Here, more than in any of his pictures, Vermeer focuses on the expression of the girl's child-like face, as she looks back over her shoulder with a questioning glance. At the same time he uses all his technical skill to reproduce the sumptuous fabrics and the large pearl that shimmers in the light.

Jan Vermeer (1632–1675)

Girl with a Pearl Earring, c. 1665–66
The Hague, Mauritshuis

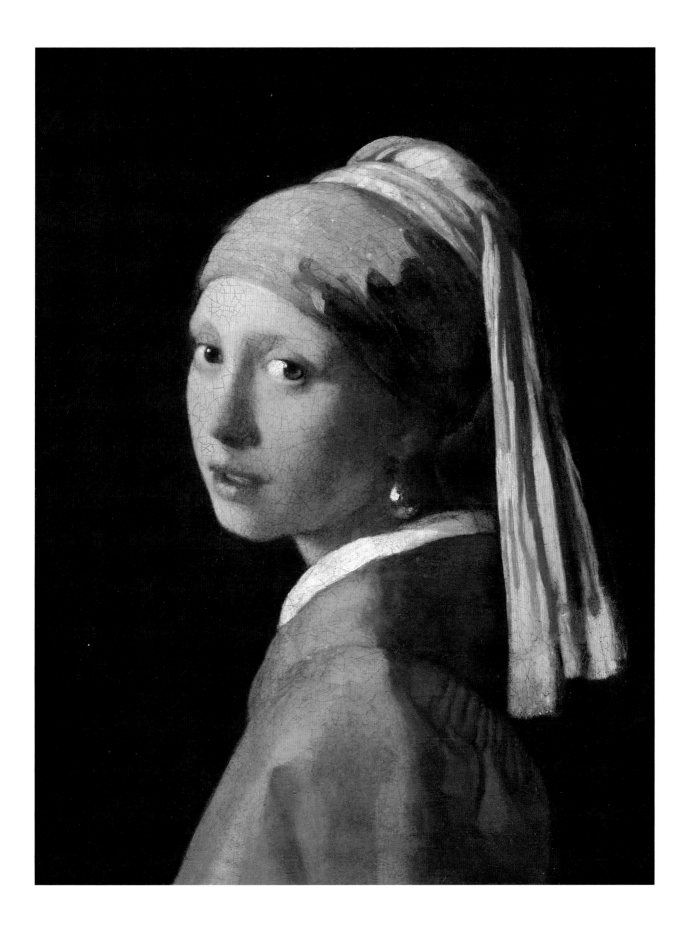

Sir Joshua Reynolds

Sir Joshua Reynolds was celebrated by his contemporaries as a genius. "To be such a painter," wrote the politician and statesman Edmund Burke, "he was a profound and penetrating philosopher." Today it is not so easy to get a sense of the terrific impact Reynolds's portraits had on viewers in Georgian times. He worked in a cool, Neo-classical style, which he taught to his many pupils in his role as first president of the Royal Academy. His main source of artistic inspiration was Phidias, the Greek sculptor who created the famous frieze on the Parthenon temple in the fifth century BC. Reynolds did not want to follow his fellow painter William Hogarth in documenting the consumerist, fashion-crazy society of his day. Instead he sought to present the 'ideal nature' of his subjects, and from the 1740s onwards he followed this credo in paintings of aristocrats, parliamentarians, military commanders, writers and actors — and such high-class courtesans as the legendary Kitty Fisher, who was supported by a large number of gentlemen clients. This attractive daughter of a working-class family unleashed a wave of 'Fishermania' in London: young women imitated her style of dress and journalists wrote obscene verses to her in the press. Reynolds, too, succumbed to her charms: nine portraits of her have survived. In 1759 he painted her as the Egyptian ruler Cleopatra, who is about to dissolve one of her pearl earrings in a goblet of vinegar in order to seduce the Roman commander Mark Antony.

Sir Joshua Reynolds (1723–1792)

Kitty Fisher as Cleopatra, 1759
London, Kenwood House (The Iveagh Bequest)

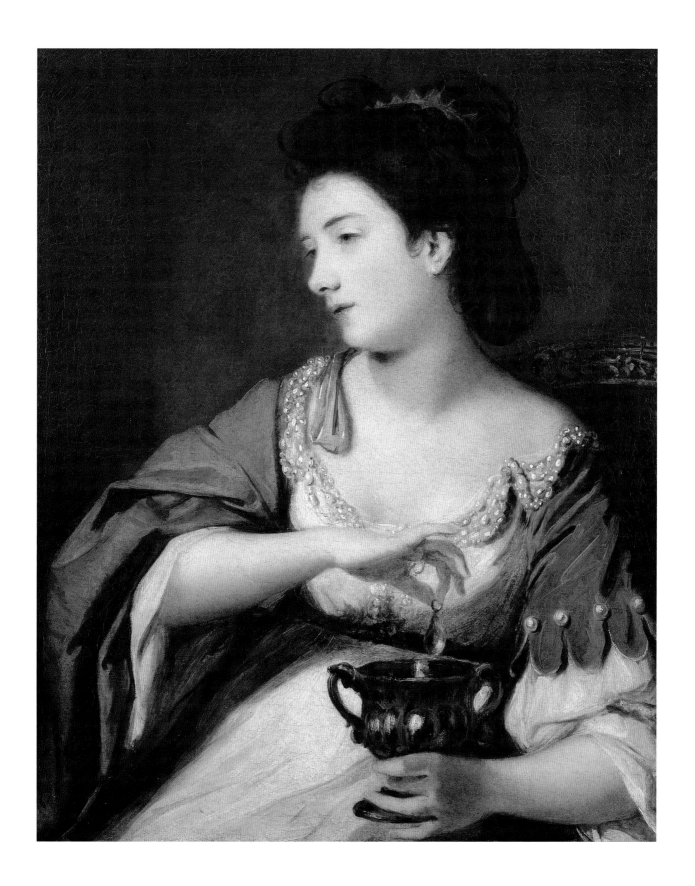

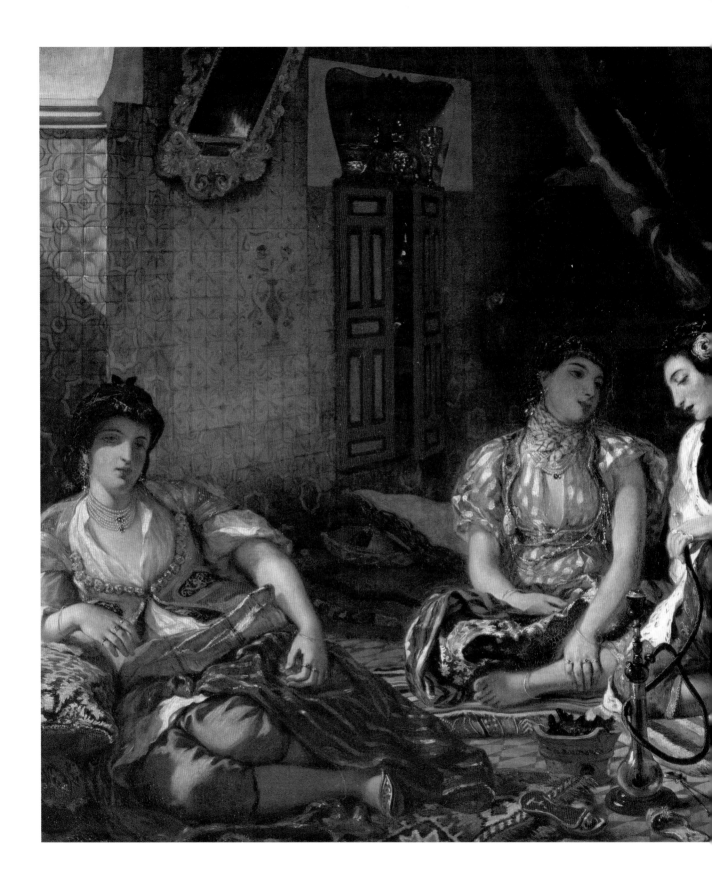

Eugène Delacroix

After the French occupied Algeria in 1830, King Louis Philippe attempted to settle the resulting dispute with Morocco by diplomatic means. In October 1831 he sent a delegation to conduct peace negotiations with Sultan Moulay Abd-er-Rahman. Before photography was invented it was usual to send painters on this kind of trip to document events. Eugène Delacroix was offered the job and accepted with alacrity. On 1 January 1832 the mission travelled from Paris to Toulon, where they embarked on the ship La Perle and sailed to Tangiers. Delacroix was astounded by the exotic world he discovered there. He recorded his impressions of street scenes, people and landscapes in his sketchbooks and diaries. On 29 February 1832 he noted: "This is a country for painters. Politicians ... would have a great deal to criticize regarding human rights and equality before the law; but the beauty here is overwhelming." The Frenchman had few chances to see the legendary beauty of the women, but just before his return journey he was able to visit a harem in Algiers. "The woman in the harem looks after her children, spins wool, or embroiders the most magnificent fabrics. That's the kind of woman I understand!" he is said to have exclaimed. On his return to Paris, Delacroix captured the magnificence of the interiors and costumes in his painting of the harem women.

Eugène Delacroix (1798–1863)

Women of Algiers, 1834
Paris, Louvre

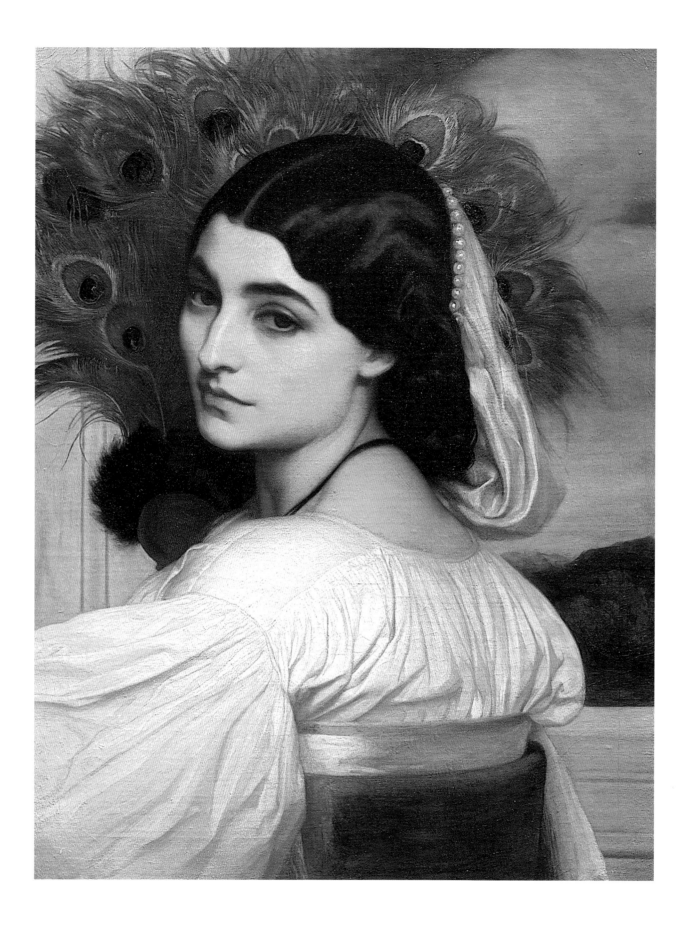

Frederic, Lord Leighton

"Her proud gaze is worthy of a Lucretia Borgia." Such was the verdict of the art critic F.G. Stephens in *The Athenaeum* when this picture was exhibited at the Royal Academy in 1859. Whether Lord Leighton's peacock woman was actually intended to represent a society lady like the notorious Italian aristocrat Lucretia Borgia is a matter of controversy among experts. The feather fan which contrasts so strikingly with the pale face need not be interpreted as a symbol of social status. Peacock feathers are traditionally an emblem of Juno, the Roman goddess of marriage and birth. They can also signify immorality and, because of the eyes, watchfulness. The subject's social standing is not clear even from her clothing. In contrast to the elegant pearls of her hair ornament and her satin shawl, her robe looks almost rustic. Yet one thing is beyond doubt: this painting is a monument to female beauty. Lord Leighton met his breathtakingly beautiful model during his stay in Rome. Anna Risi, known as Nanna, was the lover of his fellow painter Anselm Feuerbach and famous for her statuesque looks and melancholy air.

Frederic, Lord Leighton (1830–1896)

Pavonia, 1858/59
Private collection

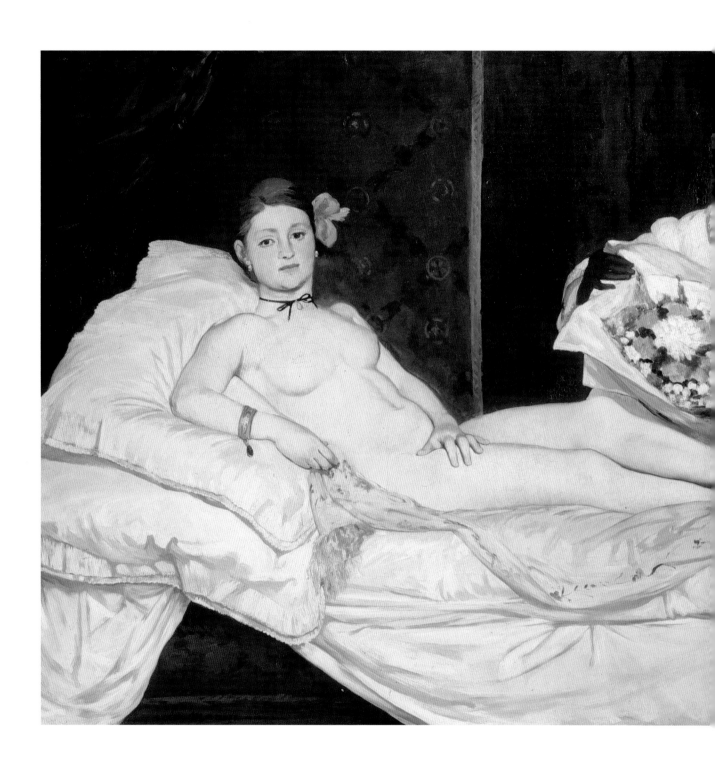

Edouard Manet

This painting created a furore when it was shown at the Paris Salon of 1865. First, the slender nude model did not at all conform to the concept of beauty prevalent at the time – the art critic Amadée Cantaloupe said she made him think of a "female gorilla", because the dark outline made him think of body hair. Secondly, Edouard Manet had borrowed the iconic design of Titian's *Venus* of Urbino to depict a well-known Paris prostitute, Olympia, who also worked as a life model for the painters in Montmartre. Manet made no attempt to conceal the profession of the woman on the couch: quite the opposite. Numerous details allude to her dubious position in society: the orchid in her hair can be interpreted as a sexual symbol because of its similarity in shape to the female genitals. The model's extremely white skin is a reference to the fact that prostitutes were known in France as *filles de marbre*, girls of marble. The black servant was regarded by contemporaries as a standard feature of a courtesan's household; here she is bringing a bouquet of flowers to her mistress, who is wearing nothing but shoes and a pearl necklace. The cat at the foot of the couch takes the place of the little dog in Titian's painting. This cat has often been linked with the poem *Le Chat* (The cat) by Charles Baudelaire, who was a friend of Manet, especially with the lines: "In spirit I see my woman. Her gaze, like yours, dear creature, deep and cold, cuts and splits like a dart."

Edouard Manet (1832–1883)

Olympia, 1863
Paris, Musée d'Orsay

Franz von Stuck

Before Franz von Stuck rose to become the leading painter of Munich society he came to public attention through a huge scandal. In 1895, a reproduction of his painting *The Sphinx's Kiss* was removed from an art dealer's window on police orders. In the eyes of pious local shopkeepers, the subject — a passionate kiss between a young man and the mythological half-woman, half-lioness — was a danger to public morals. Nor did it help Stuck to point the finger of blame at the poet Heinrich Heine, who had provided inspiration for the picture in the following lines: "She almost drank my breath away — and finally, begging for ecstasy, she embraced me, tearing at my poor body with her lion's claws." It was not only with this painting that Stuck caused feelings to run high in the city; his whole concept of art was controversial. Some people saw his maenads and drunken fauns, his personifications of sin and sensuality, as immoral or simply crass. Others celebrated him as a unique talent. "If the people of Munich had their way," wrote the journalist Eduard Engels in 1901, "Stuck would be listed in Baedeker under the town's attractions — and given three stars, too."

Franz von Stuck's picture of the biblical character Salome belongs in the 'sensual and immoral' category. Her stepfather Antipas was so entranced by her provocative dance of the seven veils that he promised to grant her any wish. Under the influence of her mother Herodias, Salome called for the head of John the Baptist, and it was presented to her shortly afterwards on a golden dish.

Franz von Stuck (1863–1928)

Salome, 1906
Private collection

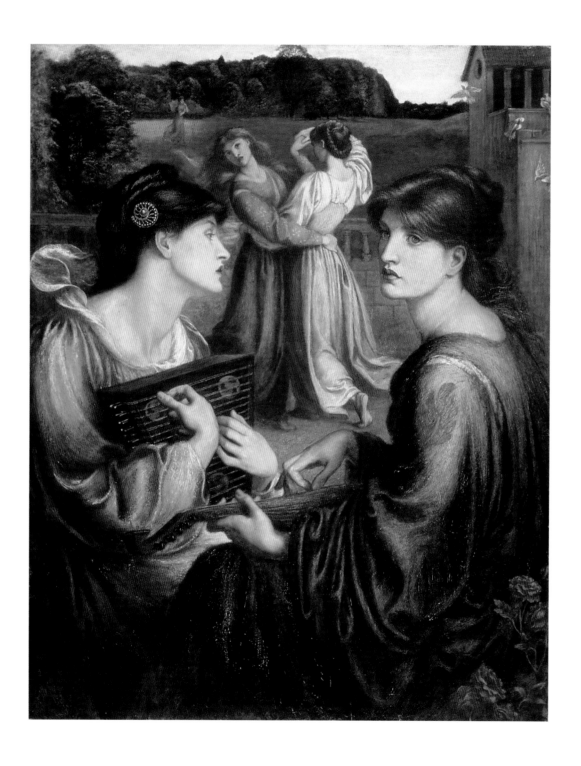

Dante Gabriel Rossetti

Dante Gabriel Rossetti was one of the founding members of the Pre-Raphaelites, a group of Victorian artists dedicated to reviving the style of religious art of the Middle Ages, before Raphael. However, when Rossetti realized that his moral paintings, such as the scenes from the childhood of the Virgin Mary, were having no success on the art market, he promptly switched to a different kind of subject. From the 1850s onwards he focused entirely on the celebration of female beauty. The sources of inspiration he drew on for his scenic paintings were the medieval legends surrounding the Celtic King Arthur, Dante's *Divine Comedy* and the contemporary poetry of Algernon Charles Swinburne. After the death of his young wife Elizabeth Siddal, who had modelled for him in a wide range of roles, Rossetti maintained a harem of muses who conformed to his ideal of beauty: almond-shaped eyes, sensual lips and a long mane of hair were the prerequisites to please this bohemian character, who kept peacocks and armadillos at his country house. Rossetti's artistic heroes were the Venetian Renaissance painters Titian and Giorgione. In Victorian art theory their rich palette of colours was compared with the harmonious effect of a piece of music. In *The Stones of Venice* (1851) John Ruskin wrote: "When an artist touches colour, it is the same thing as when a poet takes up a musical instrument." The fabulous colours of Rossetti's idyll *The Bower Meadow* perfectly illustrate Ruskin's comparison.

Dante Gabriel Rossetti (1828–1882)

The Bower Meadow, 1872
Manchester, Art Gallery

John William Waterhouse

Like Dante Gabriel Rossetti, the Pre-Raphaelite John William Waterhouse, who was born in Rome, also drew inspiration from English literary history. It took him seven years to paint his famous *Ophelia*, depicting the heroine of Shakespeare's *Hamlet*. Here the young woman sits lost in thought on the bank of a dark, lily-covered stream, decorating her long hair with flowers. Ophelia is the innocent victim in this tragedy: Hamlet abruptly rejects her love because he is obsessed with wreaking vengeance on his uncle Claudius, who has poisoned Hamlet's father and married his mother in order to become king of Denmark. In the confusion of intrigues and murder plans the prince also kills Ophelia's innocent father Polonius. She falls into despair and madness and ends her life by drowning herself.

John William Waterhouse (1849–1917)

Ophelia, 1894
Private collection

Christian Schad

"I painted this nude during the July holidays, in a hotel on Boulevard Raspail in Paris. It was very hot and both of us were sweating profusely, because the window faced south-west and had no shutters. Fortunately, the model was my friend Maika. No one else would have borne the heat. Maika had skin like mother-of-pearl. In order to accentuate the fresh, vital quality of her skin we purchased a factory-made accessory from a street seller – this red and white necklace," recalled Christian Schad in his diary in 1929. Maika came from Oldenburg and lived in Berlin from the mid-1920s onwards. From 1928 to 1931 she was friendly with Schad, one of the leading figures in the *Neue Sachlichkeit* (New objectivity) movement in Germany. He had just one subject: people. During the 1920s he painted society figures and colourful characters from the theatrical world in a cool, Classicist style. Maika was not, as has often been asserted, a starlet of the UFA studios in Berlin. She did work in films now and then, but as a high-class extra: she owned expensive, elegant clothes which she donned, for a fee, to play walk-on parts in appropriate film scenes.

Christian Schad (1894–1982)

Half-length Nude, 1929
Wuppertal, Von der Heydt-Museum

Symbols of Power
Princesses and Queens

No queen would dream of being painted or photographed for a formal state portrait without her crown jewels. This is just as true for today's political first ladies as it was for the rulers of past centuries. Alongside diamonds and other gems, the standard regalia always included strings of pearls, and crowns and robes set with pearls. Outstanding individual pearls — such as the egg-shaped La Peregrina, found off the coast of South America — changed hands over the course of history, belonging to various ruling families in Europe: emperors and kings could afford to own such legendary jewels only for as long as state finances permitted.

Piero della Francesca

B attista Sforza was just fourteen years old when she was
married to Federico da Montefeltro, duke of Urbino. Her
education at her parents' court in Pesaro had prepared her for
high office. It included studying the Classical languages, as Latin
was the main language of diplomacy in the fifteenth century.
Contemporaries unanimously describe her as an intelligent
ruler, and an able substitute for Duke Federico in all state matters
when he was called away by his duties as *condottiere* — commander —
of the army of the Italian Liga in times of war. She fulfilled
her wifely duty when it came to providing an heir: Battista was
pregnant nine times during her fourteen-year marriage, giving
birth to eight daughters before she delivered the longed-for son
in 1472. Piero della Francesca was the official court painter in
Urbino and wrote theoretical works on geometry and perspective
in painting. Here he shows the couple in half-length and in stark
profile, against an imaginary landscape with many castles. This
formal double portrait was probably produced in the 1460s.
Piero della Francesca was one of the first Italian Renaissance
painters to set his subjects against a landscape view, under the
influence of Dutch portraiture.

Piero della Francesca (1420–1492)

Federico III da Montefeltro, Duke of Urbino, and his Wife Battista Sforza, c. 1460s
Florence, Uffizi

Hans Eworth

When Mary Tudor became queen of England in 1553 it was against all odds. Henry VIII had declared his elder daughter illegitimate after divorcing the first of his six wives, Catherine of Aragon. In her youth Mary was an outsider at court: she was forbidden to have any contact with her mother or to use the title 'princess'. Only on his deathbed did Henry, now married to his last wife, Catherine Parr, restore her to the succession. Following the death at sixteen of her half-brother Edward VI, Mary inherited the crown. Her father had dissolved many monasteries and distributed their lands and wealth among the English nobility. Mary's goal was to bring the newly formed Anglican Church back within the confines of Roman Catholicism, and she was determined to re-establish the pope's authority. Following a conspiracy by her political opponents, led by the Protestant Thomas Wyatt, she had all the 'heretics' burned at the stake, a course of action that earned her the sobriquet 'Bloody Mary'. The Dutch painter Hans Eworth produced this portrait of the Catholic queen a year after her coronation. Around her neck she wears La Peregrina, which was given to her by her husband King Philip II of Spain.

Hans Eworth (1540–1573)

Mary Tudor, 1554
London, National Portrait Gallery

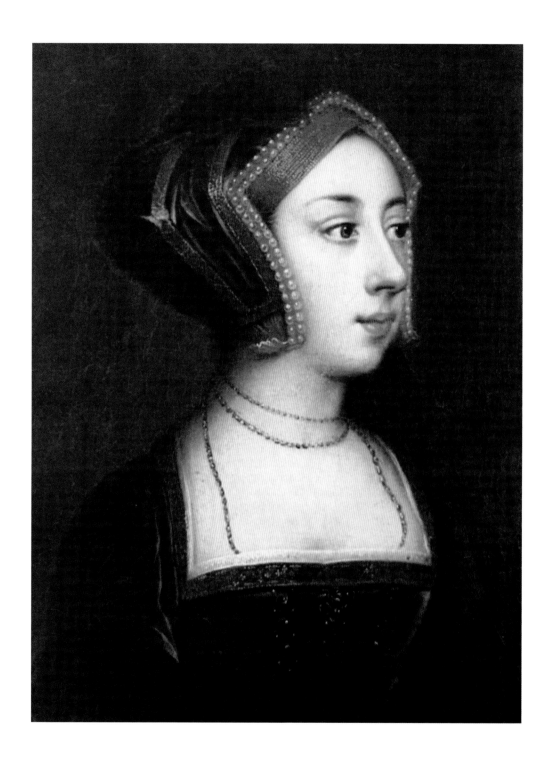

Hans Holbein

Henry VIII went so far as to break with the Catholic Church in order to marry Anne Boleyn. He met and fell in love with the raven-haired Anne, then a lady-in-waiting to his wife Catherine of Aragon, around 1522. Not only was she extremely attractive, but contemporaries also describe her as highly educated, quick-witted and creative. Henry, who needed a male heir, was determined to marry Anne and declared his first marriage invalid, against the will of Catherine and without the necessary approval by the pope. He was excommunicated as a result, but the king had prepared for this eventuality with his Act for the Submission of the Clergy: from 1532 onwards he, rather than the pope, became the highest authority in the English Church.

Hans Holbein the Younger came from Basel, where he produced his famous portrait of Erasmus; he probably painted this portait of Anne Boleyn before her wedding in 1533. The subject is set against the neutral background typical of Holbein, and the artist concentrates entirely on the objective reproduction of her features and clothing, including a fashionable headdress set with pearls. The bride-to-be looks out on the world attentively. At this stage she could look forward to her imminent social advancement and a future as queen of England. However, when she suffered two miscarriages following the birth of her daughter Elizabeth in 1533, leaving Henry still without a male heir, she fell into disfavour. She was tried on multiple charges of adultery – with no evidence whatsoever – and was beheaded in the Tower for high treason in 1536.

Hans Holbein (1497–1543)

Anne Boleyn, c. 1533
Kent, Hever Castle

Elisabeth Vigée-Lebrun

The eighteenth century has been called the 'Century of Women'. If a woman was talented and (above all) beautiful this was an era when many opportunities were open to her, as illustrated by the painter Elisabeth Vigée-Lebrun's glittering career. She was born in Paris in 1755. Her mother was a famous hairstylist, her father a painter. By the age of fifteen, she was already earning her own living as a professional portrait painter. And because she was not just highly talented but also very beautiful, she soon attracted the attention of various gentlemen of the court. In 1776 she married the successful art dealer Jean-Baptiste-Pierre Lebrun, who helped to secure portrait commissions from the aristocracy as well as introductions to King Louis XVI and his wife Marie-Antoinette, whom she painted more than twenty times. This professional success quickly became a liability, however, on the outbreak of the French Revolution. As a fervent monarchist, she had to leave the country in 1789. She fled to Italy, where she received a warm welcome and was able to continue her career as the most sought-after portraitist of the European aristocracy. She spent nearly two years in Naples, where she painted the famous collector of antiquities Sir William Hamilton and his mistress (later his wife) Emma Hart. She also produced this formal state portrait of the queen of Naples, Maria Carolina, in her regal finery. It was not until 1802, after years of travel – which took her as far as St Petersburg and Moscow – that the émigrée was able to return to France. Here she wrote her memoirs, *Souvenirs de Madame Vigée-Lebrun*, a lively account of the court culture of the eighteenth century.

Elisabeth Vigée-Lebrun (1755–1842)

Portrait of Maria Carolina, 1790
Fontainebleau, Musée National du Château

François Gérard

The Empress Josephine, as she became, had a turbulent life even before she met Napoleon Bonaparte. To save her parents from ruin, Josephine, a Creole born in Martinique, was sent to Paris and married to the wealthy Baron Alexandre de Beauharnais in 1779. The couple had two children but the marriage – perhaps unsurprisingly – was not a happy one. In the turmoil of the French Revolution her aristocratic title nearly cost her her life. Her husband was executed; she was imprisoned and was lucky to avoid the same fate. After this Josephine and her children were protected by her influential friends, until she came to the attention of the young Napoleon. He fell passionately in love with the widow and married her in 1796. Many surviving letters bear testimony to Napoleon's ardour. Yet even during his first military campaign in Milan Josephine betrayed him with a cavalry officer, Hippolyte Charles. The little Corsican general threatened her with divorce but eventually forgave her. In 1804 he made himself emperor; François Gérard portrayed Josephine in her new role as empress.

François Gérard (1770–1837)

Portrait of Empress Josephine, 1805–08
Fontainebleau, Musée National du Château

Joseph Stieler

King Ludwig I of Bavaria was susceptible to feminine charms from an early age. On his journey to Italy in 1817 he raved about "the eyes of Sicilian women, which glow with passion and with an unutterable yearning"; at the carnival in Rome a year later he waxed lyrical about two Mediterranean women. No wonder this legendary patron of the arts, who built the Glyptothek and Pinakothek in Munich, decided to create a monument to female beauty. In 1826 he commissioned his court painter, Joseph Stieler, to produce portraits for his 'Gallery of Beauties'. The first ten of the planned total of thirty-six portraits were completed in 1829 and displayed to the public in two rooms of the Festsaalbau at the Munich royal residence, facing the gardens, where they remained until 1944. The king himself selected the models for the portraits. They included not just court ladies but also the ordinary women of Munich — the main criteria for inclusion were outstanding attractiveness and a spotless character. Entirely in the spirit of German idealism, Ludwig I equated external beauty with high morality and human integrity, and the Munich display was by no means a 'painted harem', as the poet Heinrich Heine waspishly described it. Ludwig maintained that even his relationship with the dancer Lola Montez — a high-spirited Irishwoman, despite her Spanish name — was purely platonic. One of the last women to be included in the Gallery of Beauties was Crown Princess Marie of Bavaria. She had married Ludwig's son Maximilian in 1842 and became queen of Bavaria in 1848, after Ludwig's abdication.

Joseph Stieler (1781–1848)

Marie, Queen of Bavaria
Munich, Schloss Nymphenburg

Franz Xaver Winterhalter

Franz Xaver Winterhalter studied painting at the Munich Academy of Fine Arts, while at the same time gaining experience in the studio of Joseph Stieler: he was to become even more successful as a portrait painter than his famous teacher. He received his first major commissions from 1828 onwards in Karlsruhe, where he was appointed court painter to Grand Duke Leopold of Baden. He lived in Paris after 1834, where the support of the 'citizen king' Louis Philippe and his successor Emperor Napoleon III quickly established him as the most popular portrait painter of Paris society and the European aristocracy. In 1865 he painted this state portrait of Olga Nikolayevna, Queen of Württemberg. She was a descendant of the Russian tsars and considered Württemberg's lowly position in the European political pecking order as somewhat beneath her dignity. To keep up the appearance of a prospering kingdom she had herself painted in this highly formal pose. She stands upright, against a landscape backdrop, and her sumptuous dress is lavishly adorned with heavy strings of pearls. Bismarck's assessment of her political ambitions was: "The Queen is the only man at the court of Stuttgart." Olga Nikolayevna put this energy to good use in advancing the cause of women in Württemberg, and in 1883 became patron of the Swabian Women's Association's School of Women's Work.

Franz Xaver Winterhalter (1805–1873)

Olga Nikolayevna, Queen of Württemberg, 1865
Stuttgart, Württembergisches Landesmuseum

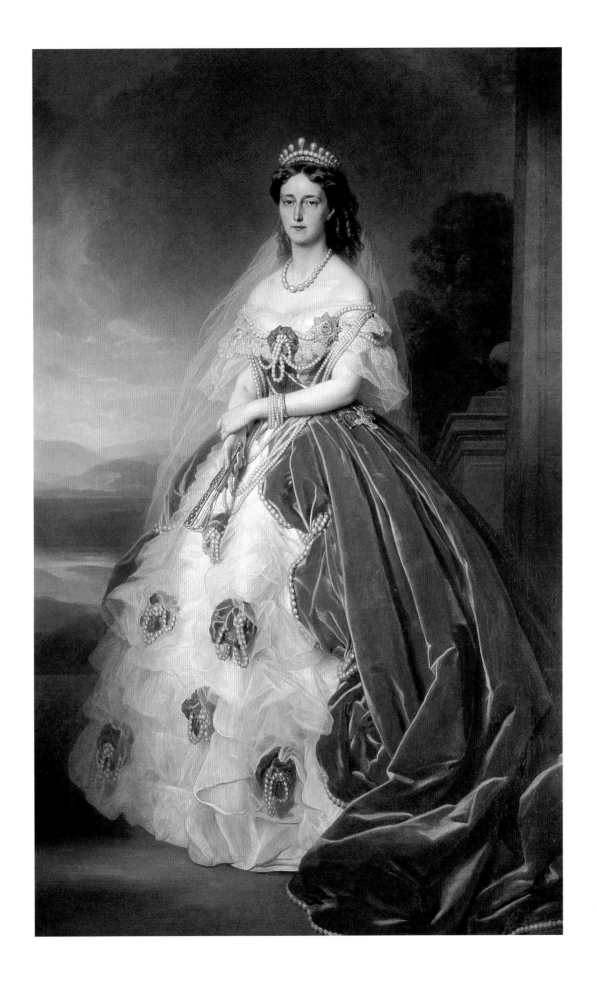

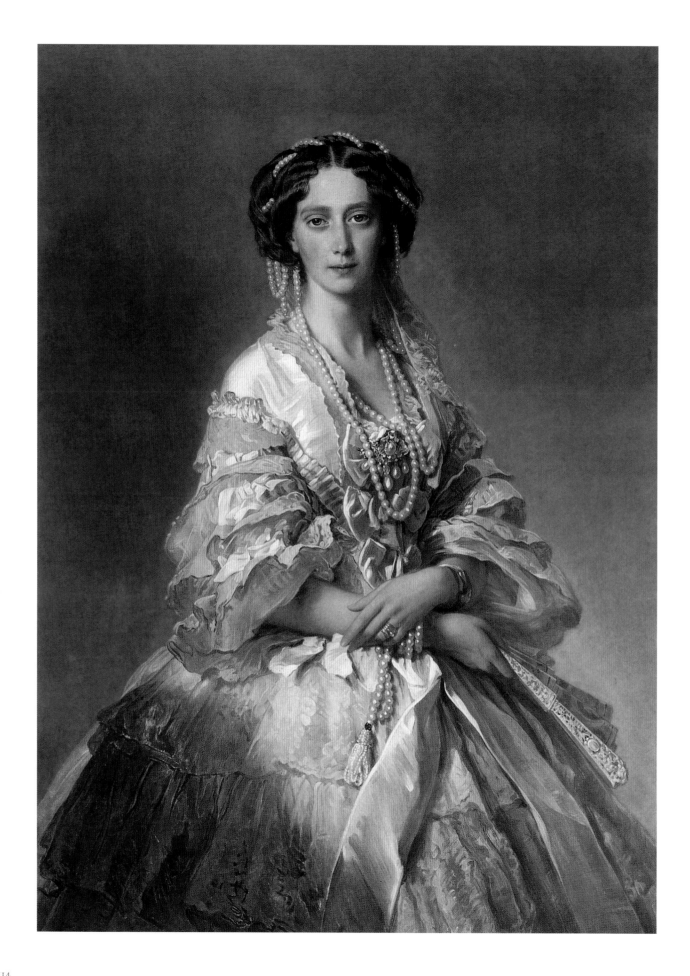

Franz Xaver Winterhalter

Winterhalter painted everyone who was anyone in his time. As well as painting the Empress Elisabeth of Austria he also portrayed Princess Marie of Hesse-Darmstadt, who married the Russian Tsar Alexander in 1841. She ascended the throne with her husband in 1855 and influenced him politically with her forthright attitude and liberal views. Winterhalter produced this portrait when she was staying at Brückenau in Bavaria, a spa resort that became very fashionable with the Russian aristocracy in the nineteenth century. As in his portrait of the queen of Württemberg (see page 113) he gave particular prominence to his royal subject's pearl jewellery. A string of large round pearls is woven into Maria Alexandrovna's dark-brown hair, while several strings of pearls fall in heavy cascades to her waist and beyond. Winterhalter used a very limited palette of colours and avoided stark contrasts. The tsarina wears a white dress which almost merges into a pale grey background reminiscent of a bleak winter sky. The brightness of the picture accentuates her graceful, ethereal appearance and gives her an almost saint-like radiance. The Russian imperial couple were enthusiastic about the result: "So you must be satisfied," wrote Duchess Tolstoy, a friend of the tsarina, to the painter in 1857, "because the Tsar and the Tsarina were both delighted!"

Franz Xaver Winterhalter (1805–1873)

Tsarina Maria Alexandrovna of Russia, 1857
Darmstadt, Schlossmuseum

Princess Eugénie

The British press reacted with sarcasm to the love match between Napoleon III and the Spanish Countess Eugénie de Montijo (1826–1920): "We learn with some amusement that this romantic event in the annals of the French Empire has called forth the strongest opposition, and provoked the utmost irritation. The Imperial family, the Council of Ministers and even the lower coteries of the palace or its purlieus, all affect to regard this marriage as an amazing humiliation…", commented *The Times*. In Paris, however, the new princess quickly became a trend-setter. She wore lavish dresses made in sumptuous fabrics, designed by Charles Frederick Worth, and started a new craze for coloured pearls. The empress owned a particularly large (13-carat) pink pearl discovered by an American carpenter in a freshwater mussel in Ohio in 1897. She also loved to wear a necklace of black Tahiti pearls, which were considered especially rare.

Unknown photographer

Princess Eugénie in Oriental Dress, before 1865
New York, Metropolitan Museum of Art,
Gilman Paper Company Collection

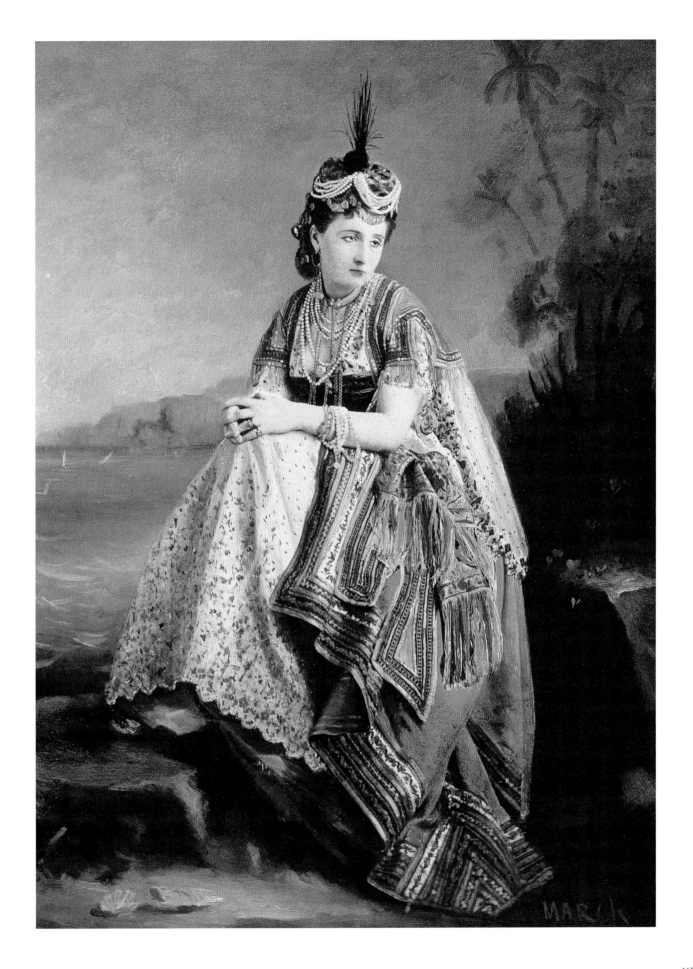

Elisabeth of Austria

The Empress Elisabeth of Austria (1837–1898) is better known in the German-speaking world as Princess Sissi — a character immortalized by Romy Schneider in the *Sissi* film trilogy (1955–58), directed by Ernst Marischka. However, Elisabeth's marriage to the Emperor Franz, and her equine escapades and travel adventures, did not quite match up to the idyll presented in the three films. Elisabeth remained an outsider at the imperial court all her life. Having enjoyed a liberal education and a happy youth by Lake Starnberg with her brothers and sisters of the Bavarian royal family, free of state duties, she found it difficult to conform to the ceremonies and strict procedures of Viennese court life. Added to this was the fact that her mother-in-law, Archduchess Sophie, was highly reluctant to relinquish her position of power. Elisabeth was not granted any political influence and her three children, Sophie, Gisela and Crown Prince Rudolf, were given to the care of a lady-in-waiting as soon as they were born. Sissi's response to these restrictions was to set off on extended travels to Madeira, Greece, England and Hungary. She did not return to the imperial family in Vienna until 1861, by which stage she was absolutely determined to do battle for her rightful status at court. She made use of her good looks — her beauty was famed in her own time — in order to win public sympathy and widespread support. The empress developed an almost obsessive cult of slenderness and beauty, as the many portraits of her show. The touch of instability inherent in the Wittelsbach family manifested itself in her eccentricity and, to a much greater extent, in the behaviour of her son Rudolf, who killed himself with his lover Mary Vetsera at Mayerling in 1889. Elisabeth herself was stabbed to death while on holiday in Geneva, Switzerland in 1898.

Unknown photographer

Empress Elisabeth of Austria aged Seventeen, 1854

Daisy of Pless

Daisy of Pless was a leading society figure in the years before the First World War. She was beautiful, rich and cultured, and among her friends were the most powerful men of her age, including King Edward VII and the German Kaiser Wilhelm II. In 1891 she married the German prince Hans Heinrich von Pless, who was rumoured to be richer than the Kaiser, and moved to his castle, Schloss Fürstenstein, in Silesia. Here, at the foot of the Sudety Mountains, the *schöne Engländerin* (beautiful Englishwoman) received the leading figures of the European aristocracy, regaling them with concerts, golf, hunting parties, and firework displays in the terraced garden. Yet she did far more than this: she achieved a great deal on behalf of the Waldenburg mine workers, and she launched a project to clean up the rivers of Silesia in order to combat the regular outbreaks of typhoid and cholera among the workers. During the First World War she worked as a Red Cross nurse and accompanied hospital trains. She recorded all the details of her adventurous life in several volumes of diaries, which were published during her own lifetime under the title *Daisy Princess of Pless by Herself*. In this photograph she is wearing her famous string of pearls, seven metres (21 feet) long – a gift from her husband, purchased for the incredible sum of three million Goldmarks (about £150,000/$720,000 at the time).

Unknown photographer

Daisy of Pless wearing the Pless Pearls, c. 1900

Giovanni Boldini

Giovanni Boldini painted the leading figures of the Belle Epoque in such a shimmering, delicate, feverish style that his brushmarks almost seem to prophesy the downfall of his clientèle in the First World War. The artist was born in Ferrara in 1842 and launched his brilliant career as a high-society portraitist in Florence, where he met his artist colleagues and potential clients from English society in the famous Caffè Michelangelo and Caffè Doney. Within a few years he had risen to become a leading portraitist of the ladies of the period. After extended stays in London and the United States he finally settled in Paris in 1871, where his friends included Degas, Manet and Sisley. In 1898 he was commissioned to paint the Spanish Infanta Eulalia. The only problem for the experienced portraitist was that the princess – an intelligent, sharp-witted character – by no means conformed to the ideal of female beauty Boldini celebrated in his paintings. After six months he was still not satisfied with the result of his efforts, so he visited a dressmaker himself and had a new outfit made for the princess to replace the elegant black dress she had been wearing. The white lace of the new dress flattered her striking features, and he was able to finish the portrait to his satisfaction.

Giovanni Boldini (1842–1931)

Princess Eulalia of Spain, 1898
Ferrara, Museo Giovanni Boldini

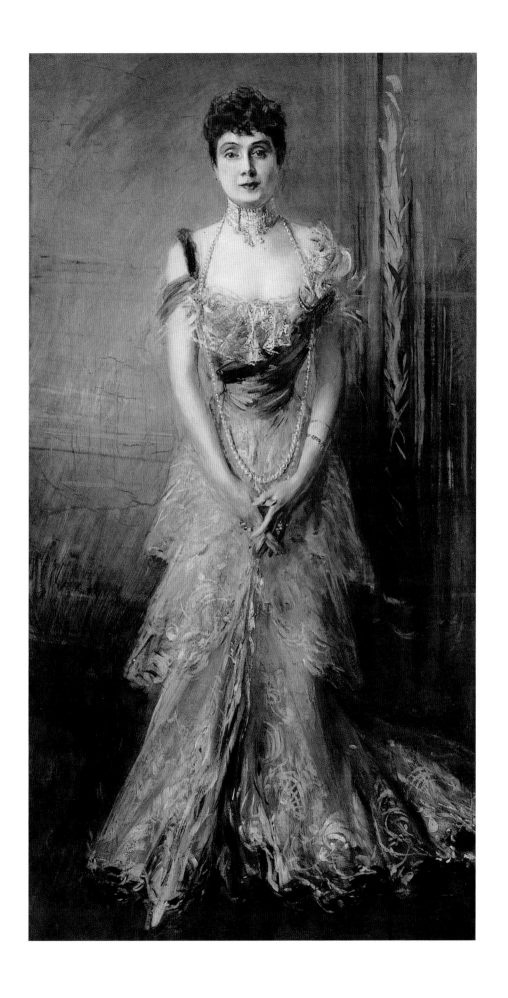

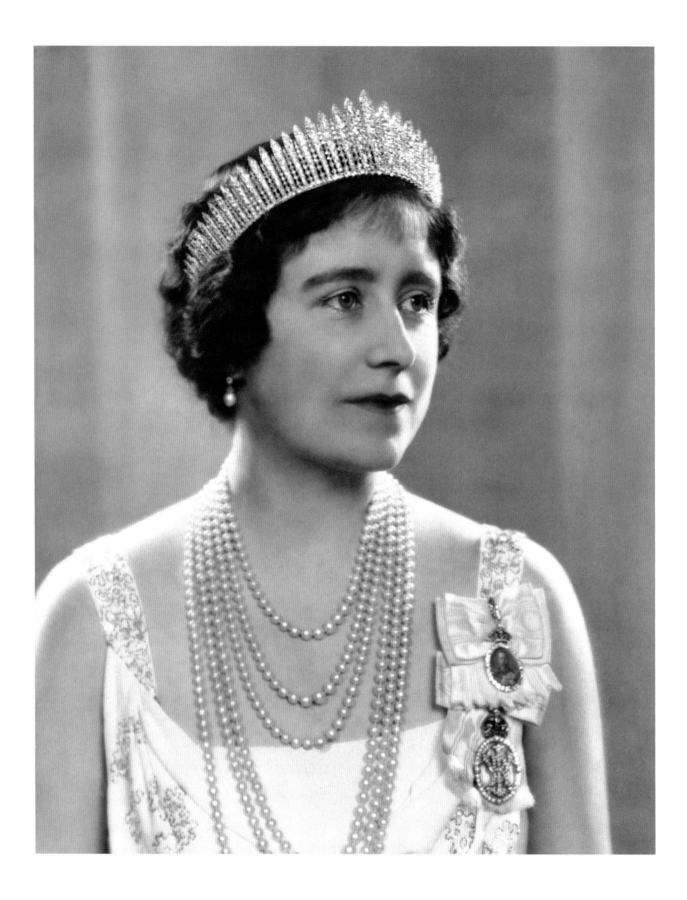

Dorothy Wilding

Elizabeth Angela Marguerite Bowes-Lyon, the Queen Mother (1900–2002), was an enduringly popular member of the British royal family. Affectionately known by the tabloids as the 'nation's favourite grandmother', and famous for her trademark outfits of pastel chiffon, her passion for racing and her fondness for gin, she kept smiling through all the various *faux pas* committed by her grandchildren. Queen Elizabeth captured the hearts of the British people during the Second World War. Despite the heavy bombing endured by London she refused to flee to safe exile in Canada. With her daughters Elizabeth and Margaret and her husband King George VI she continued to live in Buckingham Palace. When a bomb hit the palace the queen said to her soldiers: "I'm almost glad that we've been bombed. At least I can look the East End [of London] in the eye."

Dorothy Wilding took this black-and-white state photograph of the young Elizabeth in 1937, to mark her husband's coronation. Wilding, a professional portrait photographer, was the first and only woman to be appointed Official Royal Photographer for the coronation ceremonies. The young queen wears a diamond tiara, pearl earrings and a six-string pearl necklace.

Dorothy Wilding (1893–1976)

Queen Elizabeth, Queen of King George VI, 1937
London, National Portrait Gallery

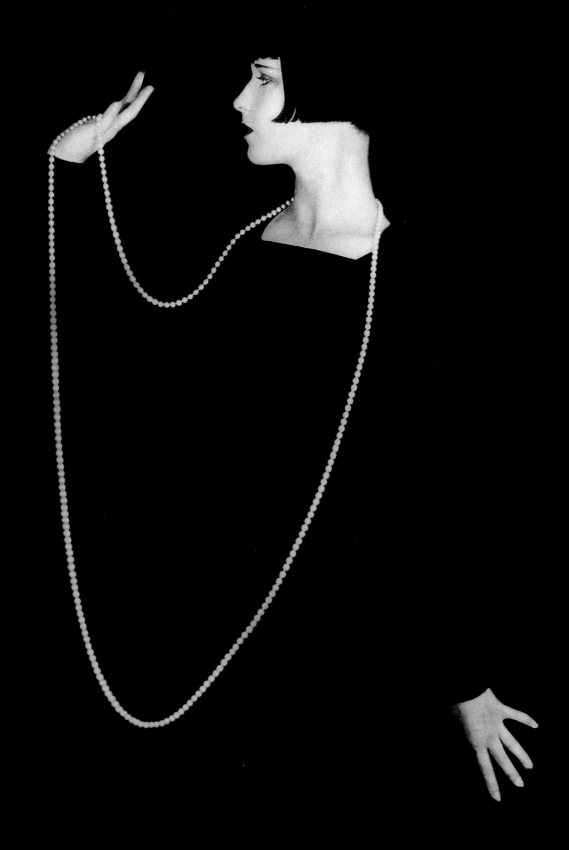

Emblems of Beauty
Divas and Icons

As Japanese cultured pearls took Europe by storm, pearl jewellery became an everyday accessory, an accessible emblem of femininity and elegance. The fashion designer Gabrielle 'Coco' Chanel was the style pioneer for twentieth-century pearl-wearers. Theatre stars, silent-movie divas and actresses also wore clothes and necklaces set with pearls to highlight their grace and beauty. By this stage the treasures from the sea had become more affordable, but they had not lost any of their mythical aura: they continued to epitomize natural beauty and aesthetic perfection.

Baron Adolph de Meyer

"I want to be a living work of art" — this tenet helped Marchesa Luisa Casati to create for herself one of the most glittering lifestyles in Europe in the first three decades of the twentieth century. She invested every last lira of her inherited fortune in pursuit of an extravagant, exhibitionist way of living. The tall, red-haired marchioness appeared at parties accompanied by a pair of cheetahs on diamond-studded leashes, or with her pet boa constrictor. And her own receptions were legendary: she amazed her famous guests (who included Pablo Picasso) with nude servants whose skin had been covered in gold leaf. Whole generations of artists were captivated by this woman, whose life was her art. Giovanni Boldini and Kees van Dongen painted her several times, the Italian Futurists appointed her their muse, such authors as Gabriele d'Annunzio and D.H. Lawrence drew inspiration from her for characters in their novels, the fashion designers Mariano Fortuny and Erté created designs exclusively for her, and she was photographed not only by Adolph de Meyer but also by Man Ray and Cecil Beaton. In 1930 Luisa Casati was the proud owner of the Palazzo dei Leoni in Venice (now the Guggenheim Museum) and of the Palais de Rose just outside Paris. However, her lavish lifestyle had piled up a mountain of debt — in total, $25 million (about £5.25 million at the time) — and eventually all her possessions were confiscated and auctioned. After this the incorrigible eccentric lived in more modest circumstances in London; yet here, too, she quickly attracted a circle of admirers.

Baron Adolph de Meyer (1868–1949)

Marchesa Luisa Casati, 1912
New Jersey, The Casati Archives

Josephine Baker

When Josephine Baker (1906–1975) was not on stage dancing in skirts trimmed with bananas she liked to wear figure-hugging dresses covered with sequins and pearls. The African-American entertainer, who came from a poor background, took the stages of Paris by storm in the 1920s with her wild dances. In 1925 she was widely celebrated as the star of the Revue Nègre at the Théâtre des Champs-Elysées. In the following year she delighted her French audiences — including such artists as Pablo Picasso and Georges Rouault — with her '*danse sauvage*' at the Folies Bergère. Yet Austria and Germany regarded her as a public menace: when she performed in Vienna in 1928 special church services were held "in penance for the serious crimes against morality". She was prohibited from performing in Munich because of the anticipated "violation of public decency". And yet this high-spirited dancer was anything but a superficial showgirl. Under the Occupation in Paris, Baker used her privileged position to smuggle secret messages for the Resistance. Unable to replicate her European success in the United States, she finally returnedto France, where she adopted twelve children of different nationalities and settled in a château in the Dordogne.

Unknown photographer

Josephine Baker, c. 1925

Louise Brooks

The American actress Louise Brooks (1906–1985) achieved world fame in 1928 when she played Lulu in G.W. Pabst's silent film *Pandora's Box*, based on Frank Wedekind's play. The drama tells the story of a childlike *femme fatale*, whose untrammelled sexuality drives both men and women to distraction; she ends up as an impoverished prostitute and is murdered by Jack the Ripper. The filming of this controversial play created an uproar in Europe, mainly because of its lesbian scenes. And when Louise Brooks returned to America, Paramount Pictures parted company with their high-profile star on the flimsy pretext that her voice was not suitable for the new medium of sound pictures. In the meantime Brooks — who featured in twenty-four films between 1928 and 1934 — had long become established as a style icon, and her distinctive 'helmet' hairstyle was widely imitated. She celebrated her Hollywood comeback not as an actress but as a film critic. A collection of her film reviews appeared under the title *Lulu in Hollywood* in 1982 and shot up the bestseller lists.

Unknown photographer

Louise Brooks, c. 1920

Man Ray

Coco Chanel revolutionized fashion "with a black pullover and ten strings of pearls", as Christian Dior once said about the great lady of French *haute couture*. And indeed Chanel's formula for success — simple cuts, fabulous accessories — went right back to the start of her career. With a loan from her lover Arthur Capel she opened a hat shop, and shortly after that, in 1911, she launched her first fashion salon in Paris's rue Cambon. Here she shortened skirts, threw away the corset, and designed flattering clothes in comfortable jersey fabrics for the fashionable woman of the world. Just three years later American *Vogue* described her clothes as the "epitome of elegance" — a label that is just as valid today. Although Chanel described herself as a private person ("I can count on my fingers the number of large dinners I attended"), she mixed with the most famous artists of her time. Her friends included the artists' muse Misia Sert, the writer Jean Cocteau, the painter Pablo Picasso, the Russian ballet impresario Sergei Diaghilev and the composer Igor Stravinsky. Man Ray, the photographer and one of the founders of the Surrealist movement, portrayed the designer in 1934/35 with the tools of her success: a black dress and pearls.

Man Ray (1890–1976)

Coco Chanel, 1934/35

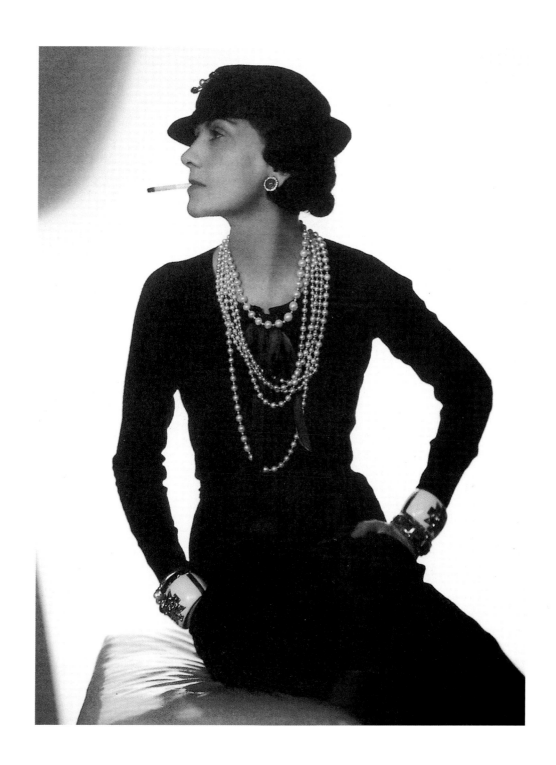

Marlene Dietrich

More than anything, Marlene Dietrich hated being asked to talk about her life – her answers were generally monosyllabic. Whenever the film diva discovered that a biography was in the pipeline she took legal action against the would-be authors. As a result she was always the subject of wild speculation: in the 1940s she was variously said to be a Nazi spy or working for the Americans; in the 1950s some felt that she had betrayed the Germans; and no one knew her true age. Marlene Dietrich was born in Schöneberg in Berlin in 1901. When a tendon inflammation forced her to give up the violin she joined Max Reinhardt's acting school. After a few small theatre roles she achieved her big breakthrough as Lola in Josef von Sternberg's *The Blue Angel* (1929/30), based on Heinrich Mann's novel *Professor Unrat*. On the night of the première she travelled to the USA and signed a contract with Paramount Studios. Six more films with Sternberg followed. When Joseph Goebbels offered her 200,000 Reichsmarks (£10,000/nearly $50,000 at the time) to make any film she liked in Germany, she refused. Instead she worked with such legendary Hollywood directors as Billy Wilder and Alfred Hitchcock. In the comedy *Desire* (1936), directed by Frank Borzage, Dietrich plays a canny jewel thief on the run from Paris to Spain with her booty, a pearl necklace. To evade capture going through customs she hides the necklace in the jacket pocket of her unsuspecting American fellow traveller Tom Bradley (Gary Cooper). She then invites him to her house in order to get the necklace back, where he falls prey to her deceptive charms.

Unknown photographer

Publicity photograph for *Desire*, 1935
Berlin, Filmmuseum – Marlene Dietrich Collection

Jacqueline Kennedy

Jacqueline Bouvier (1929–1994) met her future husband on one of her routine jobs as a journalist and photographer for the Washington *Times-Herald*. In 1952 she interviewed the young Senator for Massachusetts, John F. Kennedy, and the pair were married the following year. She came from a wealthy background: she attended the best private schools in America and then studied art and literature at the Sorbonne in Paris. He was a young, up-and-coming politician. They were the dream couple then, as they were nearly ten years later when they moved into the White House. Jacqueline Kennedy took Mamie Eisenhower's place as First Lady, and the conservative role model of the 1950s gave way to a younger, bolder figure, who confidently restyled the presidential residence according to her own ideas. She decorated the impersonal rooms with authentic American antiques and tracked down portraits of such statesmen as Thomas Jefferson and Benjamin Franklin to illustrate the early history of the United States. With her exquisite taste and her love of French *haute couture* she became a trendsetter of the 1960s; her perennial accessories included the Hermès bag and, of course, a pearl necklace.

Unknown photographer

Jacqueline Kennedy, 1951

Vivien Leigh

In 1938 the whole of America was wondering who would play the part of Scarlett O'Hara. David O. Selznick had decided to make a film of Margaret Mitchell's epic novel *Gone with the Wind*, which had won the Pulitzer Prize and topped the *New York Times* bestseller list for two years. More than two thousand hopeful young stars were tested for the female lead in what was a sensationally expensive film at that time, and all the leading stars of Hollywood — Bette Davis, Claudette Colbert and Joan Crawford among them — were invited to audition. In the end the producer chose the virtually unknown British stage actress Vivien Leigh. She captivated movie audiences both as the spoiled daughter of a plantation owner, with her doomed passion for her brother-in-law, and as the strong woman who fights for her life and for Tara, her family plantation, during the chaos of the American Civil War. Both the book and the film appeared in times of economic hardship, and many women were therefore able to identify with Scarlett's courage and tenacity. Clark Gable, playing Rhett Butler, felt that he was not being shown to best advantage during filming, however, and summarily had director George Cukor replaced with Victor Fleming.

Unknown photographer

Vivien Leigh, 1955

Maria Callas

"Simply ridiculous for such a girl to want to be a singer" was the verdict from Elvira de Hidalgo when a chubby teenager with thick-lensed glasses asked the famous Athens singing teacher for lessons. Yet the young Maria Callas was soon celebrating successful premières in Europe. In 1947 she starred in Amilcare Ponchielli's *La Gioconda* in Verona, and there she met her future husband, the Italian industrialist Giovanni Battista Meneghini, who put everything he had into furthering her career. "La Scala in delirium" was the headline in the Milan daily papers in 1954. By now Callas had become a virtuoso singer, a very beautiful woman and an inspired operatic actress. In 1957 she recorded the role of the Chinese princess Turandot in Puccini's eponymous opera. On the cover photo Callas appears in a magnificent stage costume set with filigree brooches and pearls. The lavish headdress with exotic flowers and butterflies gives her the aura of an Oriental ruler. However her steely, defiant expression reflects the character she is portraying: Turandot gives all the princes seeking to marry her three riddles to answer, and if they fail they are publicly executed.

Unknown photographer

Maria Callas, record cover of Puccini's *Turandot*, 1957

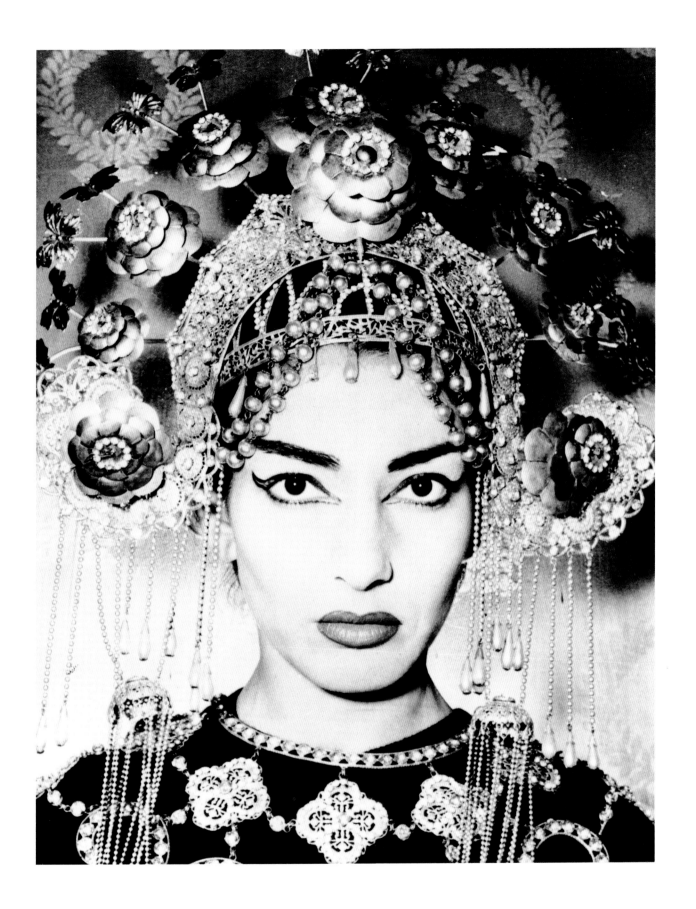

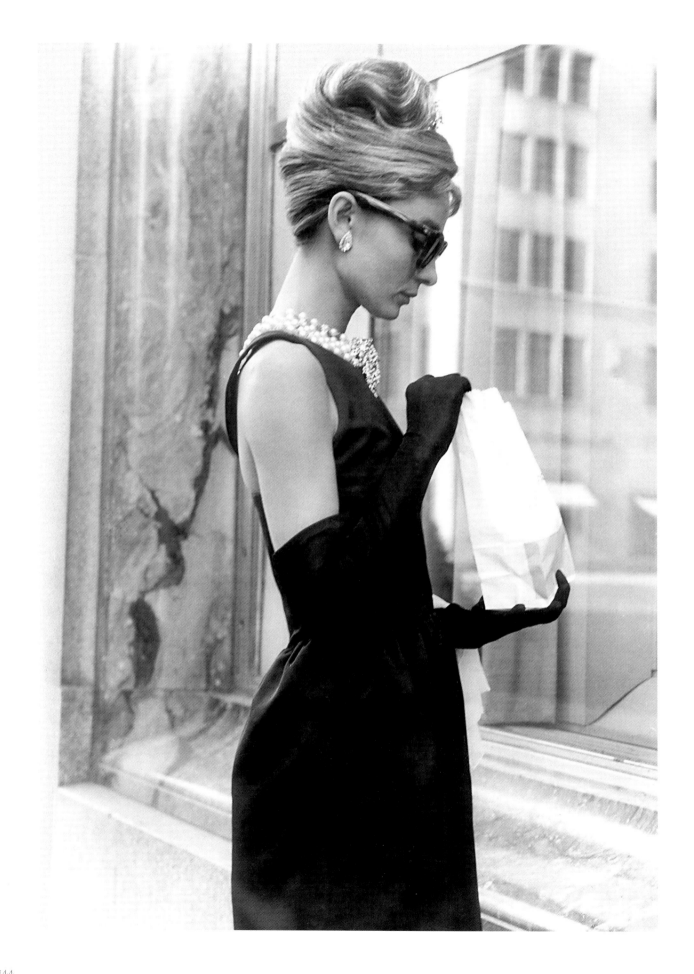

Audrey Hepburn

Dawn on Fifth Avenue, New York. Holly Golightly, played by Audrey Hepburn in *Breakfast at Tiffany's*, has a bad attack of the blues, and can only be soothed by visiting her favourite jeweller. With her coffee-to-go and her breakfast in a paper bag she dreams of better times as she looks at the window displays – a rich man, perhaps, so that she can trade in her fake jewellery for some real pearls from Tiffany's. Audrey Hepburn was born in Brussels in 1929. For women of the 1950s and '60s she provided an ideal role model – graceful and elegant, but also plucky and strong – and the fashions to match. Hepburn helped to make short hair fashionable, as well as ballerina pumps, roll-neck jumpers, tight capri pants, and a knotted blouse plus a little scarf. The hitherto unknown actress received an Oscar for her very first film, *Roman Holiday* (1953). In contrast to her curvy Hollywood rivals, Audrey Hepburn's attraction was her boyish figure. "This girl may make bosoms a thing of the past," said the eminent film-director Billy Wilder.

Paramount Pictures

Audrey Hepburn in *Breakfast at Tiffany's*, 1961

Marilyn Monroe

Unlike many other Hollywood stars, Marilyn Monroe (1926–1962) truly deserves to be called an icon. She became immortal not just for her films but also for her much-photographed image. She posed for the cameras more effectively than any other star and did not shield her private life from the omnipresent lenses of the paparazzi. Even her famous husbands – baseball star Joe DiMaggio and bestselling playwright Arthur Miller – paled into insignificance by her side. Three images of Monroe were etched on the collective memory of the twentieth century: the 'Golden Dreams' calendar shot which became the first *Playboy* centrefold in 1953; Marilyn in a white pleated dress standing over a New York subway airvent, a scene from the film *The Seven Year Itch*; and Andy Warhol's *Gold Marilyn Monroe* portrait of 1962. Yet the photographer or artist portraying her was never the centre of attention: he or she was merely permitted to participate in the icon's fame. This photo shows a typical Monroe pose. Her head is thrown back, her décolletage is seductively to the fore, and the strap of her halterneck dress is entwined with pearls.

Unknown photographer

Marilyn Monroe, 1950s

Index

Picture Credits